Advance Praise for

"Painting Resilience: The Life and Art of Fred Terna"

Eloquent and moving. Not many of us can witness to the witnesses, but Julia Mayer's intimate cross-generational account of Fred Terna's story as artist and Holocaust survivor makes clear that even across many generations, it is possible to carry this legacy forward. — *Laura Levitt, Professor of Religion, Jewish Studies and Gender, Temple University. Author of "American Jewish Loss After the Holocaust" (NYU Press, 2007); and "The Objects that Remain" (Penn State University Press, 2020)*

"Painting Resilience: The Life and Art of Fred Terna" allows Terna to generously share his experience before, during, and after the Holocaust through both his recollections and artwork, all with great honesty, insight, and sensitivity. — *Museum of Jewish Heritage — A Living Memorial to the Holocaust*

Julia Mayer's "Painting Resilience: The Life and Art of Fred Terna" interweaves the language of the art works and the personal stories of Fred Terna and his first wife Stella who survived Terezin and Auschwitz. The biography addresses traumatic memories of survivors that one can never escape. — *Renate Evers, Director of Collections, Leo Baeck Institute New York*

"Painting Resilience" is a story about family, human injury, suffering, death, life, beauty, and extraordinary strength. In these pages, I feel artist Fred Terna's indomitable spirit, his profound wisdom, and considerable insights about life before and during the Third Reich. Perhaps, more importantly, in them, I see lessons germane and apropos for today. — *Willa M. Johnson, Ph.D., Associate Professor of Sociology, University of Mississippi*

In "Painting Resilience," the talented Julia Mayer depicts recurring motifs running through Fred Terna's work, and explores how life and art intersect before, during, and after the Holocaust. Taking you inside Terna's studio to understand his process and his philosophy, Mayer invites you to share in her and Terna's deep personal rapport. — *Kate Chertavian, Founder, Kate Chertavian Fine Art*

Painting Resilience: The Life and Art of Fred Terna

ALSO BY JULIA MAYER

Eyes In the Mirror

(2011)

Painting Resilience: The Life and Art of Fred Terna

Julia Mayer

JBJ Vision LLC, Boston, 2020

Published in the United States by JBJ Vision, LLC, Boston, MA.
Mayer, Julia B.
Painting Resilience: The Life and Art of Fred Terna

ISBN 978-1-735-8762-1-4 (hardcover)
ISBN 978-1-735-8762-2-1 (paperback)
ISBN 978-1-735-8762-0-7 (ebook)
Library of Congress Control Number: 2020919168

Book and cover design: Naomi Berger

For Brian.

With gratitude for our past and hope for our future.

Table of Contents

List of Included Artworks

Part 1

In the camps we promised each other that the one who survives would tell the story. Within my limits I have done my share. More important perhaps is my example that painful and destructive memories do not exclude a happy and productive life. . . .

— Fred Terna

Introduction
(2019)

Fred Terna has been a fixture at my family's holiday table and at our synagogue on Saturday mornings for most of my life. Growing up, I knew he was a full-time artist, but did not know he had been painting for more than 60 years. I didn't realize that his work was frequently shown in galleries throughout New York City, either solo or grouped with other post-impressionist artists, or that his work is in many major Holocaust museums around the world, including the United States Holocaust Memorial Museum in Washington, DC and Yad Vashem in Jerusalem.

Fred and his wife of over 30 years, Rebecca, often spend two of our larger family holidays with us: Passover and Rosh Hashanah, the Jewish New Year. Rebecca commands an audience while Fred is reserved. My mom maintains that there is an unwritten agreement that if Fred talks, everyone listens. Naturally soft-spoken with a Central European accent

from his native Prague, Fred is sometimes willing and able to tell stories about his past. Other times, he's not. It's something he's honest about and I learned to check when he arrived, "Can I ask questions tonight? Are you up for talking tonight?"

I never needed to clarify that what I really meant was, "Can I ask about the Holocaust tonight?"

Starting when I was a teenager, Fred, then in his 80s, offered to take me on tours of his art studio in Brooklyn. A savvy New York City kid, I had a pretty specific idea of what it meant when an older man asked a teenage girl to "tour his studio." After years of asking, he eventually gave up.

I was a recent college graduate when it occurred to me to ask Fred if his offer for a tour still stood. He readily agreed. I was living in Boston and working for nonprofits I cared about deeply. I had a serious boyfriend, Brian. Brian's grandfather survived World War II in hiding and his grandmother had escaped but was the secret-keeper of many others' stories that she never shared. I now wear the diamond that his grandfather took into hiding with him during the War and which he gave to Brian's grandmother when he proposed. My own grandparents fled Germany in 1935 and 1940; many of those they left behind perished. My grandfather died before I was born and my grandmother was so overwhelmed by guilt, remorse, and sadness that she kept much of her history to herself. My grandfather on the other side was part of a division of the American army that liberated a concentration camp called Ahlem. He spoke to me about it only once, but for the rest of his life he said Kaddish, the Jewish prayer for mourning, for those he buried in a mass grave. For Brian, my older brother Jesse, and me, the

idea of spending the afternoon with someone who could talk about his experiences was a special one. I scheduled a tour when all three of us would be in Brooklyn.

On a brisk sunny day in February 2014, Brian, Jesse, and I managed to find a parking spot right across the street from Fred and Rebecca's four-story Brooklyn brownstone. Rebecca, 23 years younger than Fred, was away skiing. Fred welcomed us. In the entryway was a beautiful painting made of short pastel lines on a long light canvas. I complimented it, and Fred thanked me and told us this was how he remembered one of the mass graves from his time in the camps. Fred walked us through the artwork on his walls and currently in progress in his studio and gave a short demonstration of how he mixes acrylic paints. One of us asked if we could keep asking questions, and Fred agreed. We sat with him in his studio: a large bright room on the top floor filled to the brim with art supplies, labeled notebooks of Fred's work, slides, photographs, works-in-progress, and much more.

We asked questions and Fred answered. Instead of asking about the war, falsely thinking we knew that story already, we talked about his life afterwards, about living with the trauma he had experienced. With prodding, Fred opened little glimpses into his life, snippets of time after liberation. He also told us an abbreviated story about the night of his liberation, a shocking tale built on coincidence after coincidence that allowed him to survive a night few would.

Fred said that after his liberation, he moved back to Prague where he had grown up. I couldn't understand it. How does one go from near-death in a concentration camp to regular daily life in Prague? I pressed him on it and he insisted the story wasn't interesting and politely

declined to answer my questions. It's in that moment that this book was born.

Over the course of the following week, I drafted a letter to Fred asking him to embark on this project with me. My initial proposal was that I assist him in writing his own memoir, perhaps doing background research or pulling together materials. I wrote a letter instead of asking him in person because I worried that the offer might seem out of the blue and he would feel pressured to say yes.

Fred called me almost immediately after receiving the letter. He was interested but needed to speak to Rebecca and their son Daniel before deciding. Daniel's support would prove integral. It was ultimately Daniel who organized and (unless otherwise noted) photographed the works included throughout the book, as well as capturing and providing the photos of Fred and his studio in the coming pages.

Starting in 1998, Fred had written many short vignettes about his life and history that he would be happy to share with me as a starting point; these often felt tailor-made for me, written in English and focused on short, distinct memories I could look through then ask questions about. I quote these notes throughout this work. Still, he said long-form writing was not his interest or forte and he would prefer I write his story. At the end of the call, he mentioned that while he appreciated my long hand note, at 91 years old, he found e-mail a rather faster means of communication, and suggested that we use that going forward. Almost every message I received from him over the next four years would contain at least one new vocabulary word for me. His first message read (in part):

Following your letter and our recent telephone exchange I talked to Rebecca and Daniel. The gist of our discussion was the agreement that you and I should go on with your writing about my past. I shall do my best to let you have the information you may want or need. Daniel has a good idea about my pictorial data, and you may want to discuss these aspects with him. These include photos, films, my paintings, drawings, and a gallimaufry of other works.

Gallimaufry: a confused jumble or medley of things.[1]

And so for two weeks that summer and many weekends over the intervening years, we delved into Fred's past and his artwork together. Each day when I arrived at Fred's house, we brewed a pot of coffee and carried our two mugs upstairs to his third-floor studio, Fred trailing his hand along the white wall next to the staircase. Sometimes I recognized the symbols in a piece hung on the walls for the first time and asked to stop and hear more about it on the way upstairs.

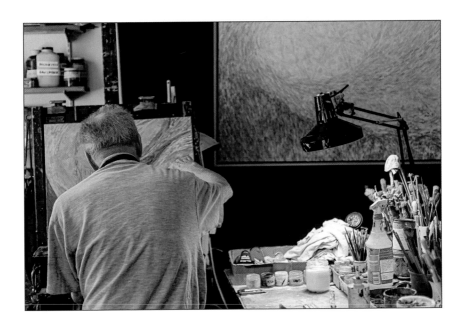

Each day, we settled in together in the place Fred feels most at home: his studio. Boston Globe art critic Murray White says "For most artists I've known, the studio is a real-world extrusion of the one inside his or her skull."[2] If this is true of Fred, and it is easy to say it is, Fred's studio shows an ordered thinker constantly at work on something new. It is large, bright, and covered in paint splatter. He keeps a few in-progress pieces on the floor and sometimes the one he's most actively working on on an

easel by the windows. Above the easel, rows of meticulously labeled jars hold acrylic paint powders; they are in old jam jars, gallon size plastic jugs, and jars that once held tomato sauce or juice. Next to the shelves of jars, a black curtain hangs over one wall to allow for high quality photos of pieces when they're finished. A table in front of this holds paint brushes, tape, sketches, canvas, spray bottles of water, and other necessary tools for his artwork.

The wall on the other side of the room is taken up by a huge bookcase filled with binders and notebooks. What initially appears chaotic is in fact exactingly sorted, labeled, and organized histories of Fred's works. He tells me many times that my next artist biography will be harder because most people don't keep records like his. A row of thin, lined, yellowing books house the remaining records of his work, each labeled along the spine with the numbers of paintings included inside. When I ask for more information about a piece, Fred checks the number on the back, pulls out the appropriate notebook, and can tell me the size, when it was finished, and whether anyone has expressed interest in purchasing it. The first notebook starts at painting number 4301 and is labeled "To 1965" the last starts at painting 6217 and begins in 2006. Binders of lectures Fred has given about the Holocaust and Jewish biblical themes take up most of the wall, each labeled with its own topic. The remaining shelves are filled with boxes labeled with anything from "Misc. Wedding Photos" to "Misc. Biblical Iconography" in Fred's careful handwriting.

For interviews each day, we sat at the second table in the studio. Fred sat on the swivel chair at his computer. From where he sat, he could see the works waiting to be photographed behind me. From the stool across the table from him, I saw pictures of Daniel, a painting of a ram, and a small American flag. He told his story, bit by bit, hour after hour. He spoke

with little emotion, though when either of us got overwhelmed we took a break by searching through his expansive art archives. Some days, we would break because he had a series of works in mind to show me, while on other days I would ask to go back to certain pieces and hear more of an explanation about them. Sometimes one of us (usually me) was just so upset by his story that looking at his work provided the distraction we needed to get back on track.

Our days were timed around Rebecca's calls, which came every hour and a half like clockwork. The second call meant it was time for us to eat lunch: bread from the refrigerator, cheese, a few grapes, or sandwiches I brought for us. We filled a water jug and brought it back upstairs, where we would talk for two more calls from Rebecca before I departed for the day.

A week into our initial time together, I fell in love with a particular painting, *Resilience*, which was so recent, Fred had not even signed it yet. When I asked to buy it, Fred said it was too expensive for me. Would I want a smaller version? He pulled out similar smaller paintings, putting them on the easel so I could see them properly. I wanted *Resilience*. We negotiated. He ultimately agreed to a price but only if I paid over 10 years in affordable installments I am still sending. The piece watches me, at times applauding what I'm trying to do while at other times, it taunts me from my living room as I struggle to complete this work.

It was the height of the Obama presidency, a hopeful time for me and, I believe, for Fred. Over the course of working together, a groundswell of nationalism formed in this country, and Donald Trump was elected President. The stories Fred told me – about the time leading up to the war, the importance of watching out for each other and of not giving in

to the desire to protect myself at the expense of others – suddenly felt all too relevant.

I am not a Holocaust expert, but I have become a Fred expert. Through our many hours together, I have learned about Fred's trauma and the choices he makes that have allowed him to live for more than seven decades without being consumed by that trauma. It is that expertise that I hope to share in the pages that follow.

RESILIENCE, 2014
Acrylic on canvas, 40 x 48 inches

Many of the symbols seen in this canvas will be unpacked in other works throughout this book: a circle holds hope and fright at the top, a seed that symbolizes new beginnings on the right side, the darkness of evil and flames at the bottom giving way to light and hope at the top. I see an angel's wings one day and the Red Sea parting to allow the Israelites' Exodus from Egypt the next. It feels like a work unto itself most of the time but occasionally it feels lonely, as if this canvas has been removed from the center of others.

Chapter 1

Drawing Out the Memories (1945)

On April 27, 1945, more than six years after he had gone into hiding and more than three and a half years since he was taken to his first concentration camp, Fred was liberated by American soldiers. He was 21 years old and weighed 76 pounds. He was covered in dirt, filth, and lice, and wrapped in clothing that had by then fused to his skin. He would recognize April 27th as his birthday for the rest of his life.

The soldiers tried to feed him, offering him chocolate. One asked in English what he wanted, and they were all shocked that he understood and could respond in English.

He had fallen asleep the night before listening to the sounds of war from the inside of a concrete drum, fantasizing about eating something hot. "Hot soup," he croaked out.

One of the officers nodded, turned to a soldier, and sent him to get rice soup. They were all astounded that they had found an English-speaking prisoner, and Fred listened without responding as they wondered who he was, if he was of some importance. His English was from before the war and hadn't really been used since his first concentration camp, when he and his fellow prisoners had clandestinely read Shakespeare together. He kept his mouth shut and ate the soup that was handed to him. He felt more dead than alive.

The soldiers loaded him onto a truck and took him to a small sanatorium called Bad Worishofen that the Americans had emptied and turned into a place to house the wounded. He was deposited into a tub of warm water. He peeled his clothes off and scrubbed himself. It took two more rounds of soap and water in the tub before he was taken out and dressed in hospital clothes. Clean for the first time in years.

There was minimal medical care but Fred's main problem was starvation. Slowly, he was given a little bit more food every day and began gaining weight back.

Two nuns came to visit, making their rounds to the sick. Fred was still too weak to get out of bed each day, so they sat with him. The younger nun doted on him, talking about the horrors he must have lived through, how he had suffered. Fred wanted to show her how much better he had already gotten; he had gone from 76 pounds to almost 100 pounds in the weeks since liberation. To prove it, he lifted his blanket to show the strength of his legs was coming back. The young nun fainted. She had never seen a naked man.

More missionaries came, asking if he needed anything. Fred requested

paper and paints and they returned with watercolors for him. He hoped he could draw the memories out of his head. He painted chimneys and smoke from Auschwitz, drew what came to his mind's eye when he thought of his last six months in Kaufering, thought of the long lines in Terezin, the barracks in Lípa. He looked through what he had drawn and painted and felt stuck in the camps. He worried he would never get out if he kept painting what he remembered.

The war was over, he told himself firmly, it was time to look ahead, not behind. He would have a future. For weeks, he tried to draw that future: landscapes, big open fields, vistas, anything he could do to move out of the camps. But as he flipped through the sketchbook, something caught his eye. Even his representations of open landscapes had hidden walls in them. Walls keeping him in and execution walls. Maybe he needed more time to get over what he had experienced. He believed in not too long, he could move on to lighter subjects.

As his strength came back, Fred began to walk outside. The makeshift hospital sat on top of a hill, and he decided one day to try walking down the hill. When he got to the bottom, he discovered that while downhill had been manageable, he was not strong enough to walk back up. He waited. American soldiers drove by in a Jeep and he flagged them down and asked to be taken up the hill. It became ritual: he would walk down the hill and wait in the cool, spring air. Deep breaths. Clean lungs. Eventually he would hear, "There's that man that always wants to be taken up the hill," and a car would stop for him.

When the weather turned from spring to summer, American soldiers began repatriating the ill. They handed out German army uniforms that had been dyed navy blue and stripped of swastikas. Fred asked if he

could keep the pocket-size books that had been given to him by various soldiers and missionaries, and they allowed it. All he had besides the books was a few extra pairs of underwear and socks. The soldiers loaded Fred and the rest of the men in the hospital — many of them still too weak to walk — onto stretchers and the stretchers into trucks. They lay there, two stretchers across, three up, bunked just as they had been months before in the camps, and were driven to the train stations to be sent "home."

Fred did not know what he was going home to, whether there would be family or friends who had also survived or if he was the only one. There had been no way to reach each other to share news. If he didn't return to Prague, he would never know who might have been waiting for him. Besides, where else would he go?

Fred sat on the train alone, watching the landscape around him change. He arrived at the Prague train stop, stood, and shuffled slowly off the train, holding his few possessions. When the train pulled out, he looked across the platform. The trolley stops were exactly where he remembered. He walked over to the #16 stop and waited for the trolley to take him home.

OPEN GATES, 2014
Acrylic on canvas, 36 x 36 inches

Walls appear in many of Fred's paintings. Even though they're not always the focal point, they never fully vanish. He explains, "At some point in my work, I put gates in the walls so that you could actually get [somewhere]. But then the gates started to look like the fences around the camps."

Here, Fred paints the Temple Mount, a topic he returns to over and over throughout his career in different ways. In this version, streaming sunlight illuminates darkened archways. The short strokes are similar to the technique he uses in other paintings to create flames, but with this blue and yellow color scheme, they seem joyous instead of sinister. These arches symbolize different things at different times: new beginnings, tombstones, escape routes.

Chapter 2

An Introduction to the Resistance (1938)

Fred began formally courting his first girlfriend when he was 13. They dated briefly and he fell head over heels for her. When she met another boy and ended the relationship, he was devastated. He wrote her a long letter, detailing his outrage, and his conviction that she break up with the new boyfriend for him, hoping his heartbreak would bring her back.

As any 13-year-old girl would, the recipient shared it with her best friend, a girl who had recently moved to Prague and begun attending her school. The two girls crafted a reply. She had moved on, was not interested in being with him anymore. The friend, however, was impressed by what she had read. She offered to hand-deliver the rejection letter.

She went to Fred's grandmother's house where he lived and waited

patiently while the maid called him. She handed Fred the letter and introduced herself as Stella Horner. Her family was newly in Prague from Vienna.

The Horners had left their lucrative wholesale coal business in Vienna when the Nazis arrived in 1938. Years earlier, her cousin moved to the United States and was making a life in Hollywood. He managed to get visas for several family members, but not for everyone. As the Nazis marched into Vienna, those who didn't have visas, including Stella's parents, grandmother, brother and sister, and her remaining uncles, fled Austria. Her father and uncles did not believe that her grandmother could survive the cross-ocean voyage and assumed that they would be safe in another European country, so they went together to Prague, with their children, Stella, Eva, and Fritz.

Fred contemplated the young girl delivering the letter to his doorstep. Beautiful dark hair, deep eyes. A halting smile. The rejection letter quickly lay forgotten.

Their courtship was as formal as any between teenagers in the 1930s. They held hands, snuck out, kissed. They did not spend much time at Stella's home, where her mother often fell ill and drew the shades to keep the noise and light out. The few times they were there, Fred recalls meeting Stella's grandmother, whom he could tell even then was a force to be reckoned with. He found her mother kind but shallow. Stella's family lacked some of the intellectual depth he enjoyed in his own home.

Fred describes his home in those years as that of a "typical Prague Jew." He gets frustrated with me that I don't know what that means. His father, Jan, worked in insurance, but had a Law Degree and was

an intellectual. His mother died suddenly when he was nine years old and though Fred and his brother Tommy lived with their father for a few years, Jan eventually came to realize he could not care for them alone, and placed them with a family nearby, then later with their grandparents.

Tommy and Fred spent Sundays, their only day entirely off school, with Jan. Fred recalls in the writings he shared with me when we started:

> ...taking a paddle steamer up the Vltava River for about 10 miles, having a picnic in the area, going swimming in the river, and returning with another paddle-steamer. There were smaller steamers going a shorter distance to a large garden and restaurant with a bandstand where a military brass band performed. Often such outings were in a group of family and friends. The grown-ups would sit around a large table, have coffee and cake, and talk and talk. We children were looking forward to getting 'grenadine,' club soda with strawberry syrup. There were elegant palaces, there were castles to visit within a short train ride, and there were hikes in the country, the zoo. When it was too cold, we could go to the movies. Some movie houses would show animated cartoons only. That was where we saw color pictures long before feature films were shot in color.

Jan worked hard not to spoil the boys. When they were young, they each had a scooter, and he would eventually buy each boy a bicycle. Books were the only thing available in any quantity at any time. Jan wanted them to be interested in everything. He himself spent late nights in his study, underlining and annotating books on philosophy and sociology. He was obsessed with Abraham Lincoln and had studied him in great depth, amassing a significant library of works about the American president, mostly in English, but in other languages as well. If Fred or Tommy expressed an interest in a topic, they could expect books on it to

appear almost immediately.

They played with the other children in their buildings and their neighborhood. They never noticed that they were the only Jews they knew. To them, the appearance of anti-Semitism felt abrupt. The boys went to public schools, different ones because of their age difference. Fred went to a dual-language German and Czech school; Tommy attended a school where he was taught French as a second language. Right around when Fred and Tommy were born, the Czech national census had replaced the term "nationality" with "language of everyday use," highlighting the importance of language in how Czech people defined themselves.[3] At times, it felt as if the linguistic barrier between them was more significant than the emotional barrier of being three years apart in age.

They spent afternoons together though, particularly at their grandparents' home, which was near the center of town. Their grandmother was a strong, organized woman who helped manage the sisterhood at her synagogue, arranging visits to the sick and elderly. Tommy and Fred sat in the alcove of her home and watched the town square together.

On Wednesdays, his grandmother hosted a type of salon; musician friends came over with their instruments and they sat around, smoked, drank, ate chocolates and pastries, and pulled out various pieces of music from his grandmother's collection. There were two grand pianos in the living room, and Fred and Tommy were welcome to sit and listen while the friends played. One musician would try out a new piece, and another would say, "Really? You call that an interpretation?"

"If you're so good, why don't you play it?"

And the second musician would play the same piece over, making it his own.

Fred's grandmother was atypical for Prague women of the day. She was well-educated as a young lady, not just in manners and maintaining an appropriate home, but as a thinker and an artist. Her incredible memory, one Fred possesses as well, made her a community organizer. She could remember phone numbers, dates, instructions. She could play a piece of new music once on the piano and afterwards know the piece for the rest of her life. Fred says of his grandmother, "She was kind of a freak, but a happy freak." He learned from her that women were intellectual equals to men.

Jan spoke seven languages, and slipped among them seamlessly at home, often hosting parties of Prague intellectuals, with whom he discussed not only sociology and philosophy, but also politics, literature, and science. Fred sat and listened, not interrupting, but learning whatever he could from his father and his friends as they spoke. Through this, he too picked up bits of other languages, so that by his mid-teens he could read Shakespeare in English before attending a play or study a French opera before seeing it performed.

Jan indulged the boys' artistic senses when he could. As a child, Fred had been in the Prague Opera Children's Chorus, where he sang in the evenings. When Fred was a teenager, Jan bought both him and Tommy low-end cameras as gifts.

It was never Fred's talent, but one Sunday, not long after, Jan found

Tommy with a Leica, one of the best cameras on the market and much more expensive than what Jan had given him.

"What is this? Is this stolen?" he asked

"No, not stolen! I--"

"Sit here and explain yourself!" Jan sat Tommy down on the rug in front of the mantle while Fred looked on.

"I've been taking jobs with the camera you gave me. Little ones. Just a few at first, portraits, passport pictures. They all paid! Not a lot, but something. I took the money and rented studio space to develop the pictures. Then I traded in my camera and the money I earned for a better one. Then I could take better pictures, so I asked for a little more and I traded in again. This is just the most recent one."

Jan asked to see the pictures and began thinking about what experience his son would need to work as a photographer and what connections he might have to help him.

Fred was already showing artistic inclinations of his own, though not always in ways his teachers appreciated. Even over 80 years later, Fred clearly recalls getting in trouble with the teacher when the class was asked to draw a fruit bowl and he drew the light and darkness around the bowl; how the shapes were separated from one another. The jagged lines that broke up shadows. He failed the class. His teacher was looking for a bowl of fruit.

Stella was a welcome addition to their lives and stopped in often, since she lived less than two blocks away. She and Eva were being raised to

be good Jewish housewives. She was supposed to be decorative, nice, good-looking. She played a little bit of piano. Much more typical for the time, Stella was like thousands of Viennese women who were expected to marry a man who could provide for her while she cared for their home and social lives. She was also fun. On the cusp of becoming a sullen teenager, Tommy mostly ignored her and Fred at home, but Jan was charmed and encouraged the two to spend time together when they could.

Jan was distracted anyway by the dark political climate. Through a network of socialist Jews across Europe, Jan was hearing about the trouble brewing in other countries. Without the boys living with him, he had a spare room, and Fred remembers strangers coming in from other countries, escaping anti-Semitism. They stayed for a week or two or very occasionally longer while on their way somewhere else.

Some guests appeared bruised, some with bandages. All on the run. Fred remembers one man, a judge from Germany named Eberhard Roullich. Fred recalls Roullich's story that during Hitler's takeover, the judge, being part of the court, found publicly that Hitler's actions were illegal. It was the largest act of resistance a single judge could engage in: the announcement that what was happening was not right, was not allowed. This did not stop the course of the war. And Fred recalls Roullich's boss told him to buy a train ticket and get out of the country – that after making such a public declaration, nobody could save him. In an effort to help, his boss delayed reporting him for a few hours so he could escape. Fred does not know what happened after Roullich left, though his father did his best to help refugees get overseas.

Like many others he describes to me, Fred remembers exactly how

to spell Roullich's name but unusually, I could not find any other information about him. If he is remembered by history for taking his stand, it is by another name or in another context. Though they did not identify it as such at the time, this was Fred and Tommy's introduction to the resistance.

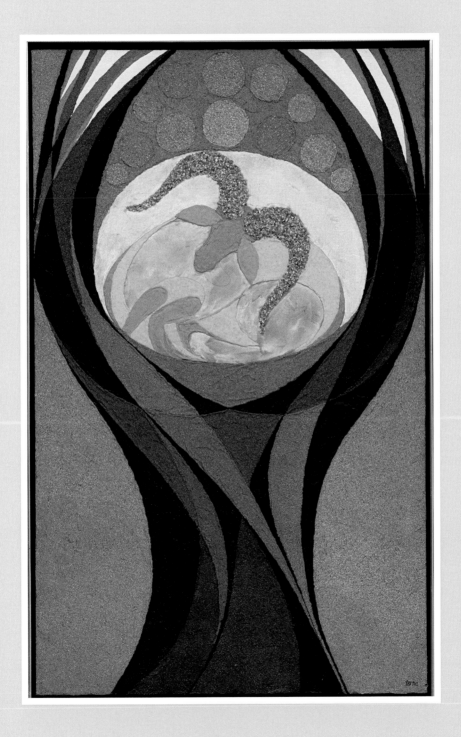

OFFERING SET ASIDE, 1973
Acrylic and aggregates on canvas, 48 x 30 inches

This is one of Fred's many paintings of rams, hearkening back to the biblical story of the binding of Isaac. Here, a ram is encircled in what appears to be a menorah, with 12 more circles, symbolizing the 12 tribes of Israel, above it. In Fred's work, the purpose of circles is often unclear. With the 12 tribes surrounding the ram, is it safe and protected by its community or stuck inside with no escape?

In creating this piece, Fred incorporated sand and pebbles to create a variety of textures. Many of his earliest works in the camps were images scratched out in sand with a stick. They were easily erased if a guard came by. Fred's use of textures, stones, sand, and sticks continued throughout his career and even led to a special gallery showing for the blind.

In this picture, each color is mixed with a different texture so it can be made out by feel as well as sight. When Fred first showed me this work, he ran his fingernails over it, and I was aghast. He saw the expression on my face and said, "It's my work, I can do that. Don't do it in a museum. But I know the quality of my work. I won't hurt it."

Chapter 3

Being Honest But Not Terrifying (1939)

I n September of 1938, the Nazis and the Allies signed the Munich Pact, giving Hitler an essential hold on Czechoslovakia. Fred and his few Jewish classmates were kicked out of school. In countries throughout Europe, neighbors and friends felt pressure to protect themselves before thinking of others. *Give in on not having Jewish children in school and perhaps they will leave the rest of us alone.* Fred tried to occupy his days with learning from the Jewish teachers and professors who were no longer allowed to teach. He learned the basics of mechanical electricity and plumbing during clandestine courses. Stella learned to pattern and cut textiles. Jan taught Fred some elementary bookkeeping based on an old Central European method. Without the structure of school, homework, and weekends, the kids barely knew what to do with themselves. If there were conversations about fleeing, Fred was not part of them. At the time, they did not know about the Nazis' willingness to kill. Fred muses now that the Nazis themselves might not have known

what the long-term plans were. There was little precedent for the mass extermination that was to follow and so, little reason to decide to run.

The only step Fred knew his father had taken was to change the family name. Legally, they had two sets of papers; they were the Taussigs and the Ternas. Jan kept both sets of papers in case a spare was ever needed, though why he felt that might offer protection, Fred cannot say. At the time, Jewish congregations themselves held the only detailed lists of Jews in the area. It's possible that his father had already seen the signs of Nazi Germany identifying Jews by connecting family members who had been members of various Jewish congregations in Prague[4]. Though Jan was not a practicing Jew, his parents (Fred's grandparents) attended synagogue occasionally for holidays, Fred and Tommy sometimes in tow. Possibly Jan recognized that the Taussig family could be identified that way and hoped that the Terna family might not. It is also possible that a second set of papers simply seemed like they would do no harm. Eighty years later, living in the unease of growing nationalism in the United States, my own father investigated a program that offers German passports to the children and grandchildren of Holocaust survivors. Who knows when or why a second set of papers might come in handy?

At 16 and prevented from going to school, Fred tried a few different jobs, finally settling on one in a furniture factory where he worked on copies of ancient furniture. The din of the factory made it an easy place to pass quick rumors. The workers shared what they had heard with each other, which Fred tried to confirm at home: the Nazis are amassing on the border; the fortifications are down; Hitler wants to occupy.

Watching his son straddle the line between child and adult, Jan struggled to share enough to be honest, but not to terrify. Once, as they reviewed

the week's news together, Fred looked over the paper at his father and in his most haughty teenage voice, asked, "Is this the world you are leaving me?" He meant the remark to be sarcastic and cutting, but it was the only time he saw his father cry.

On March 15, 1939, Fred awoke to a cold, gray day. He took the trolley to his factory job, located on Prague's main street. From his seat, he heard the planes overhead. Then hundreds of engines revving. He and the other workers lined the windows, and from there, they watched the Nazis ride into their hometown on motorcycles and in armored tanks. The mood in the factory was grim; this was the beginning of a long, hard stretch, and they could all feel things taking a turn for the worse. The factory foreman came out and told everyone to go home.

It was pandemonium outside. Everyone was on the street; all public transportation had been shut down. There were tanks where cars belonged, and orders being shouted in different languages. Doing his best to stay out of sight, bundled up against the snow that had started to fall and with his head down, Fred bustled home along side streets. When he arrived at his grandmother's house, she was crying. Unrelated to what was happening in the streets, his grandfather had died the same day.

With Prague occupied, Jan saw problems coming for his sons, and wanted Fred out of the city. He managed to secure false papers in addition to the two sets of real ones (Fred never knew how) and sent Fred to work on a farm that was a few hours by bicycle outside of the city. Perhaps he hoped that Fred could keep his head down until this blew over, that he could still help build a better world for his sons to inherit.

The work on the farm was hard labor, nothing Fred had done before. It

tired him out at first, but there was adequate food and he grew stronger over time. Fred, the consummate learner, now spent his days carrying heavy bags of freshly thrashed wheat with a labor force of mostly women and old men. The people around him were kind but undereducated. Most were only a generation or two removed from working as indentured servants for the local lord. Even the owner only had enough education to run the books of a farm.

Fred never quite fit in. He was (as far as he knows) the only Jew in town, and far better read than the people he worked with who were four times his age. He was very careful not to brag or let it shine through that he spoke five languages already, and the few books he had brought with him he hid carefully from the other farmhands.

The farm was on the Elbe River, and included what had formerly been a castle but was turned into a place to store grain. Fred had a room in the unheated castle and was usually the only one there. Food was already carefully rationed, so neighborhood thieves would stop in, trying to steal some of the grain while it was drying. Fred's presence was meant as a deterrent, though as he was unarmed, he couldn't do much more than simply be there.

In the evenings, Fred sat with the village priest and others that he considered the "aristocracy" while they played cards. The priest in particular fascinated Fred, and often the two of them discussed romantic literature of France and Germany from the early nineteenth century. Fred was unable to resist the chance to exercise his brain the way he did his muscles; he was restless and bored at the farm. These conversations may have been what called one of the farm warden's attention to him. A low-class Czech farm hand raised in the suburbs would not have studied

these works. Fred believes the warden was a Nazi sympathizer, and that he reported Fred to the Gestapo in exchange for additional rations.

While Fred was in hiding on the farm, his brother Tommy attempted to hide in plain sight. He began an apprenticeship in one of the best photo studios of Prague through a connection of Jan's. That studio was owned by a Jew who employed a gifted portrait photographer as well as a few young lab technicians. When the Nazis marched into Prague, Jews were no longer allowed to own businesses, and the photography studio was taken over by a German. The new owner had no interest in photography and did not particularly want the business, so he let the boys and photographer run it and simply exacted a monthly fee as the "owner."

The gifted portrait photographer turned out to be an alcoholic. There was Tommy, not yet 13 years old, sitting alone in the lab with a boss unable to teach him anything. The previous lab technician had left for a better job. Tommy hired a friend who also had an interest in photography. Another Jewish boy, he too had been kicked out of school and had little to do. The two of them ran the business together, not just developing pictures, but managing their drunken charge. They paid his rent and purchased his clothes and a measured amount of alcohol each week, enough to keep him happy without wasting all of their money. When he occasionally did not show up for work, they pretended to be professionals and shot portraits of the German soldiers who came in.

The two boys, out and about without their yellow Jewish stars, began coming up with schemes to do what they could to help the resistance. They purchased well-tailored upscale army jackets for the soldiers who

came in for portraits to send home to their sweethearts.

"Would you like to wear one of these jackets for your portrait? Much nicer than the standard issue uniforms."

The soldier would try on the jacket on and step out in front of the mirror. Tommy would grab the soldier's own jacket while his friend took his time cleaning off the shoulders and arranged then rearranged the soldier for his portrait.

In the back, Tommy used one of his low-quality cameras to take photos of the documents in the soldier's pockets, listening carefully to the conversation happening out front. The two developed systems to warn one another when the soldiers were moving around the shop and would question them casually about their work. In that way, they collected information about where various army units were, which they passed on with the photos. Fred never knew who the recipient of this information was.

Fred had only a vague sense then of the danger he was in and admits now he may not have been careful enough. The Czech population was quietly cooperating with German rule. The warden was one of the many collaborators in the village who might have been willing to betray anybody for small favors from the Nazis. Perhaps he justified the betrayal by thinking he could not control what was happening, that someone would have blown Fred's cover eventually anyway, that this was the way to keep his family safe. Fred's father somehow became aware Fred was in danger and sent word with a friend: Get home. Now. No delays. Fred left his books and the few things he had, got on his bicycle and began to pedal.

FOCUS ON INCLUSION, 1977
Acrylic and aggregate on canvas, 36 x 60 inches

For most of his formative years, Fred had no control over where he went, when, or with whom. Pieces like this one exemplify Fred's desire for control by showing the world around him with strong lines, and light, dark, and bright contrasting colors.

Fred says, "These are attempts to order my world. I'm in front of a canvas, trying to put some order to it… Every painter paints himself, his mind, his attitude. Every painting is a self-portrait of sorts about his or her mind."

This piece is unique in that it doesn't have a top or bottom; Fred says it could be hung any way the viewer chooses. So much of what feels in control is actually often left to chance. When we find the photo of this painting in his archives, it's hung 90 degrees from the way the actual

piece hangs in his kitchen. Ultimately, is its display a choice or is it necessity? What difference does it make?

Chapter 4

Worse than the Work was the Fear (1941)

His bicycle at the front door and sweat still dripping, Fred joined his father at their grandmother's home in Prague. He had ridden for nearly three hours, straight home from the farm, leaving his things behind. There was a knock on the door that evening.

Jan opened the door himself. Jews were not allowed to have servants, so Rosa, the family's long-time maid had been dismissed. The jobs Jews were no longer allowed to hold were vacant, creating space for non-Jews to ascend. Rosa went on to work as a streetcar conductor.

When the door opened, there were two members of the Gestapo standing there. "Where are your sons?" they asked Jan.

"They are here. Which one do you want to talk to?"

"The older one."

When Fred walked in, they realized something was wrong. The informant had been faulty. Confused, the soldiers confirmed Fred's name and age, then departed. Still, they returned a few days later to take Fred in for interrogation. Young, tired, and frightened, Fred fainted under the physical duress almost immediately. They sent him home.

A few days later, they were back to continue their questioning. The Gestapo asked Fred about people he had never heard of and places he had never been. His confusion was evident, and eventually they had to admit that they were dealing simply with a child. He did not know secrets of the resistance. Whatever was done to him while in the Gestapo headquarters, whatever was asked, whatever he said, he is completely unable to remember. In our many hours of talking about his experiences, this is the only one Fred described as a black hole in his memory. "It was hours of pain, fear, and terror. I dreaded the next grilling. I fainted several times. To this day the imprisonment by the Gestapo is a blur in my memory. I did not expect to come out alive, very few Jews did. Then, suddenly, I was let go. I have no idea why I was taken in, or why I was allowed to leave. Later in life I learned about repressed memories. Even if I could recall details today I'm not sure I want to."[5]

Fred was sent home. It was too dangerous to return to the farm now, so he remained with his father in Prague. There, German leadership in Czechoslovakia was waging war on Czech culture. Czechs who did not speak German were barred from public office and largely ousted from banks and industry. Czech clubs, schools, and universities were closed. Those who might have previously considered themselves of mixed ancestry were caught up in the tide and registered as Germans.[6]

Fred rekindled his relationship with Stella, and they looked for things to do together. Jews were being banned from one location after another: movies, parks, theaters. For a short while, they visited museums together. Eventually the "No Jews Allowed" signs went up there too.

On some corners there was green space, a few trees and a bench that were not enough to be a park. Since it wasn't a formal public space, there were no signs. They would meet on these corners and hold hands. Food shortages had started in the winter of 1940 but had gotten acutely worse so that "food coupons brought smaller quantities of basic goods like potatoes. Fruits, vegetables, meat, fat, butter, and shoes were nearly impossible to obtain, particularly so in the cities."[7] Food had become so scarce that Fred and Stella stopped going to one another's houses; the idea of asking someone else's family to feed you was ludicrous when there wasn't enough to go around.

Stories started to circulate that plagued the family. Fred's grandmother went from a strong, smart, thoughtful woman to a helpless old lady while Fred was away. Along with almost 5,000 others[8], a friend of hers was picked up by the Gestapo on false charges. They kept up hope for him until a week later when his family received a bill for his burial expenses.

When the leaders of the Prague Jewish community were given the chance to choose 50 or so boys to send out to a labor camp, it was presented to them as their chance to save these boys from a similar fate. Fred was among them, his brush with the Gestapo elevating his status with the community leadership. Less than a year after he arrived back home, there was an official notice saying that Fred was to appear with a sleeping bag, clothes, and a blanket on October 3, 1941 at a particular point in Prague. Even if they had known what was to come, the boys

would not have run; what would happen to their families if they did not appear at the appointed hour?

From the pickup point, the prisoners were put on buses to a train. The train ride wasn't long. By current calculations, the camp is about three hours southeast of Prague. Certainly the train arrived within the day. From the station, Fred marched into his first concentration camp, Lípa, or Linden bei Deutsch-Brod in German. There was, as there would be for the next four years, inadequate food, heating, and water. Fred understood that the Nazis were in need of slave labor; he knew where they were going and the type of work he would be doing by the time he got on the train. He could not have known about the death camps; that information would come later.

The United States Holocaust Memorial Museum describes Lípa as a "camp [that] was designated by Nazis as a retraining facility." According to Nazi propaganda, Jews were to be retrained there for working in agriculture and then moved to Palestine. The camp in Lípa operated in the 1940-1945 period, accommodating approximately 300 persons on average. Jews were employed on a farm expropriated from a Jewish family known as Kraus.[9]

Fred describes three barracks where the prisoners lived, with a square in the middle. One barrack was a dining area with tables and benches. On the right and left were typical barracks with triple bunks. The best bunks were reserved for the "aristocracy" of the camps — those administering rules as ordered by the Gestapo. They had the bunks built against the wall, since that offered privacy on one side. The prisoners were divided into groups randomly and Fred more or less maintained relationships within the group he was placed in.

The labor was hard, but Fred had been working on a farm. He was strong, and able to manage it. They woke at five every day for a head count in their bunks. They ate a breakfast that consisted only of "coffee," a kind of dark brewed black water that Fred would become accustomed to over the following years. Though it bore little resemblance to coffee, the water had been boiled, so the prisoners knew it was safe to drink in a place where clean water was difficult to come by.

(Though I doubt Fred noticed, it was here in his retelling of this story that I became embarrassed for the first time that I requested milk in my coffee each morning before we started.)

They were assembled in the square formed by the barracks, counted again, and marched off to the jobs they would do for the day. Then back to camp where they were counted again before dinner, which consisted of some bread and maybe a little soup.

Much worse than the work was the fear instilled by the officers. The officers slept outside the camp, with the camp surrounded by wire fencing. The officers reminded the boys they were guarding that they knew every name and every family member. If a single one of them stepped out of line or tried to escape, or missed a count, their families would suffer instead of them. Fred described the fence to me as pointless; fear was what kept them in. He said, "They could have drawn a chalk line around the camp and nobody would have crossed it." It reminds me of an experiment I did in elementary school where we drew a chalk box around an ant and it refused to cross it, walking around the box over and over while it looked for a way out. Eventually, we gave the ant a leaf to crawl onto to transport it back to its friends. There was no leaf for Fred.

Fred and his fellow prisoners did their best to remain informed about major events in the outside world, listening in on guards' conversations and stealing bits of newspaper when they could. For the first few weeks they were there, mail was not yet forbidden and mail service was working quite normally. Many of the young men received letters, and those who had remembered stamps returned them as well. Fred and Stella corresponded briefly before mail service ended.

It was while Fred was in Lípa that my own great-grandmother and great-great-aunt and uncle were removed from Germany. My great-great-uncle began his final letter to his children in the United States by saying, "I only want, as this may be my last opportunity to write to you, to write a short explanation of the sequence of events of the last year, so that you my dear children will see that we have tried everything possible to get to you." The most important thing to him was that his children not think he died because he did not care enough to try to reach them. His letter listed all of the unsuccessful methods he tried to get out. There are two P.S.s at the bottom, as they lived about six weeks longer than they expected. News like this didn't arrive until many years after the War when it was communicated via a non-Jewish neighbor. Just like in Lípa, mail service for my family had ended.

Without mail, there was little news of individuals. Fred could not have known that two months after he arrived his father and brother had already been moved to Terezin and were in their own danger more than they were in danger because of anything Fred might do.

Nonetheless, the prisoners managed to keep up on major events. Two months after their arrival, when the Japanese bombed Pearl Harbor, Fred and his fellow prisoners were talking about it the next day. They

mapped progress trying to read through the lines of the German newspapers the guards accidentally left lying around from time to time. They came to understand the shorthand the Germans were using. "Allies Defend Paris" really meant the Nazis were redoubling their efforts to march into the city. The Nazis' obsession with controlling language gave small clues: if the guards told prisoners not to discuss a country or city, it meant that was a particularly sore point.

Often the men were marched out of the camp to take care of things in the nearby town. To the people in the town, the prisoners were Czech before they were Jewish, and they were being imprisoned unfairly. The Nazi regime had realized by this time that it would be unsustainable to expel or exterminate the entire Czech population, and was focusing efforts instead on the "Germanization" of Czechs. It was safer to go along with this line of thinking than to protest and Czechs were well-versed at feigning obedience to the German government after nearly a century of battles over nationality.[10] Though they collaborated with the Gestapo to protect themselves and their families, Fred never believed that those in the neighboring towns hated Jews.

As the weather became colder, the inmates were often sent out to the mountains to clear roads of snow. They were marched out to shovel the roads, allowing trucks to get to the farm and back out with contraband food for members of the army. Sometimes there was a lunch of stale bread, often there was nothing from breakfast until their meager dinner. Like the others, Fred started to lose weight. The snow fell so hard that the piles of cleared snow were often a few feet above the prisoners' heads, and the winding road meant the guards could not always see all of the prisoners. Words passed between them more freely, and because it got dark earlier, the work day could not go on as long.

One day, when the sun was setting around 3pm, as the guards started yelling to the men to pack it in, Fred realized the banks around him were so high nobody knew he was there. He saw an opportunity and stayed hidden while the trek back to camp started. He waited until it was completely quiet before venturing to check that they were entirely out of sight, then pulled himself up onto the snowbank. He wandered around, looking for someplace he could find a little extra food; he still had the few Czech crowns he had brought with him sewn into the lining of his jacket. There had been nothing to buy since he arrived. He saw a boy outside playing in the snow. Carefully hiding his yellow star, he called out to the boy in Czech.

"Hey, I want to buy some bread, can you get some bread?"

The boy looked at the thin, sunburned man standing in front of him in freezing temperatures, then called inside, "Mom, there's a Jew out here."

He heard a woman beckon the boy into the house. He feared they might give him up, but there was nowhere to run. If he was caught, his family would perish. If he was lost, his family would perish. There was no way out of his chalk prison. He waited. The boy came back outside with a loaf of bread under his arm and offered it to Fred.

"How much?"

"My mom says it's a gift. Take it."

Fred looked down at the full loaf of bread, more food than he had held in months. He thanked the boy and asked him to thank his mother, then turned and raced back to camp. The guards were willing to turn the

occasional blind eye to a prisoner's actions if things at the camp were viewed as stable and their jobs were not put in jeopardy. Missing count was out of the question but evening count would not happen until dinner so there was still time to sneak back inside. But Fred had to find a break in the fence out of view of the guards so as not to flaunt his wanderings. Though the layout constantly changed, the prisoners managed to keep up with the Nazis' patterns and the weak spots they left open.

Even when retelling the story, it never occurs to Fred to eat the whole loaf of bread himself. That night, the fresh bread split among them, a piece for each, Fred was the hero of his cabin.

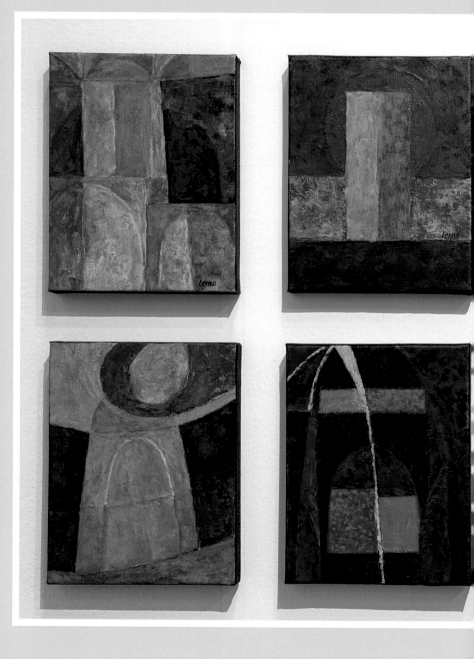

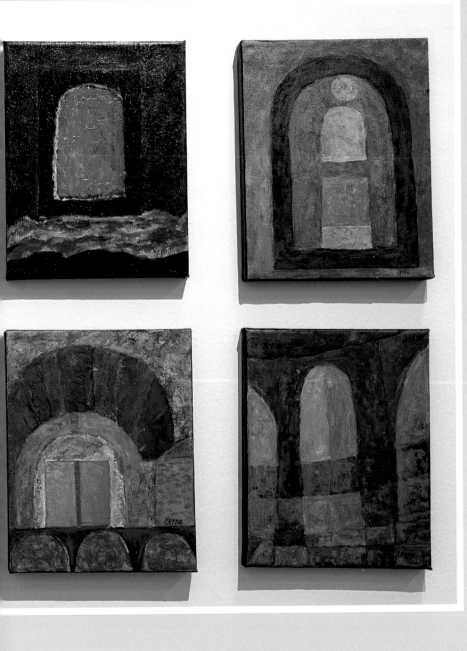

PORTALS HUNG TOGETHER (8 pieces), 2015-2017
Acrylic on cotton duck, 10 x 8 inches (each painting)

Later in his work, Fred added open portals to the fences and walls that feature heavily throughout his portfolio. Some of these pieces focus on the opening itself, whereas others include shapes seen through them that could be abstractions of people. Some even remind me of the ark in a synagogue, two doors behind which a holy Torah scroll is kept. But when hung together, one can find a dozen opportunities to cross out of or into a new world, or to sneak back in before anyone knows you're missing.

Chapter 5

Occasion to Sing
(1942)

I n Lípa, Fred found himself once more among intellectual equals.
Fred was not the only one who had been prevented from attending
school, or who wished to continue learning. Many of the men
were former college students. At not quite 18, Fred was one of the
youngest in the group, but like the others, he immediately seized the
chance to engage with well-educated fellow prisoners on a wide array of
subjects.

Fred reflects, "There was always a sense that some of us would survive.
Maybe not everybody. But whoever did survive would need all of this
information to go back out into the world when the war ended." Lípa
was not a death camp; it was a labor camp that men were chosen to enter
based on their strength and physical fitness. The certainty that he would
survive would sustain Fred for years to come and would serve as the basis
for his desire to continue learning. He and his fellow prisoners could

not have known how miniscule that surviving number would be. The overwhelming majority of young men Fred met in Lípa would not live to see liberation. Personally, Fred knows of only one.

Among the labors demanded of the prisoners in Lípa was potato picking. A large machine would drive down rows of potatoes, turning up the dirt and pulling potatoes out of the ground. The men would follow, putting the potatoes in their bags to carry to trucks. It was back-breaking work, and exhausting, done no matter the weather and without rest for days on end. There were no weekends or holidays, just constant work. To pass the time while picking, the men organized lessons among themselves. They arranged themselves in a V-shape with the teacher at the front, between the two fastest potato pickers. He would yell out the lesson to the men behind him while the fast potato pickers on either side made up for the lost picking of the teacher.

In this way, Fred learned more English, some differential calculus, and music theory. He taught sociology and history, which he had learned from his father, channeling their Sunday afternoons together into lessons for his fellow inmates. They taught each other, made up for lost time since being kicked out of formal schools, and gave one another hope that there would be use for French poetry in their lives one day. "Learning made us look towards the future, even though we were not aware of it at first. Learning gave us strength to look beyond the horror of the moment to a new life."[11]

The prisoners shared books whenever they could, though they were contraband. Each person kept just a few pages so that no one would ever be caught with a whole book. A prisoner stopped and ordered to turn out his pockets would appear to simply be carrying around a few pieces

of spare paper, essentially trash. When they assembled in the barracks at the end of the day, they put the pages back together and read what they could to one another, trading pages so that each could finish the whole book.

Many evenings, they were interrupted by a man called Lidauer, the head of the camp's Gestapo. There was a tacit understanding between him and the prisoners that if they didn't give him trouble, he wouldn't give them too much trouble either. For him, this was a cushy but low-level job. His compatriots were being killed at Stalingrad, and he was living in a villa with his wife. The camp was hard labor, but the men there were young and hearty. The guards berated the prisoners and called them filthy Jews, but they did not shoot them. Lidauer had been a butcher's apprentice before the war started and had joined the Nazi party many years earlier as a way to better his fortunes. Fred recalls him boasting about being on the team that assassinated Engelbert Dollfuss in 1934, a move which Hitler undertook in his first attempt to take over Austria. Whether it was true or not, Lidauer was trying to move up in the army and in order to advance he needed to complete certain correspondence courses. But he struggled academically.

At night, he stormed into the barracks waving around homework and exams from his classes and yelling, "You Jews are too stupid to even be able to answer this simple question." One of the prisoners dutifully took the exam, figured out the answer for him, then explained the solution. In response, the prisoner received a smack or blow to the head, and Lidauer received a passing grade. They moved him through the courses this way; a camp full of intellectually curious young Jewish boys was key to his future.

The prisoners kept up an extreme civility with one another, with pleases and thank yous, polite, kind, quiet requests of one another. To yell at a fellow inmate was to act like a guard, the worst possible insult. They maintained any dignity they could, anything to separate themselves from the Gestapo watching over them.

There was a little bit of bread and soup each day; occasionally one of the prisoners managed to sneak in some extra potatoes or vegetables the way Fred had gotten the bread. They drank the water and coffee they were given, but there was not enough water for washing themselves, and the men got continually grimier.

During the winter, since they could only work during light hours, they had far more free time in the barracks than in the summer. Time continued to pass in Lípa, with new prisoners in and old out over the course of Fred's year there. Fred met Karel Berman, a classically trained opera singer, who wanted to start a singing group in Lípa in the evenings. Fred, of course, expressed interest immediately. He hadn't had much chance or occasion to sing since his experience in the Prague Opera Children's Chorus and he embraced the opportunity for some kind of artistic outlet. Berman chose eight men, including Fred, and managed to have them reassigned to the same work group. Together, they spent their days cutting clover and other feed for the cattle out of frozen stacks that they had spent weeks creating during the summer. It was arduous work, the hardest Fred had done until then, particularly given the cold. But the team used the time to practice their arrangements, singing together in preparation for concerts put on for the other prisoners.

One barrack built as a bathroom and for showering had no running

water and provided the best venue to rehearse. The acoustics were good, and the nine men could all meet there after long days of work before returning to the barracks for the night. A lookout was set up out front, generally quick enough to alert the singers that someone was coming and to stop and remain silent. The Gestapo knew that the prisoners put on performances; they were often done standing on tables in the dining barracks, where anyone could see. The understanding among all of them allowed it to continue, but they remained acutely aware of doing something they weren't supposed to and maintained secrecy where possible.

Somehow bypassing the lookout one evening, Lidauer and his crew marched right into the bathroom where rehearsals were taking place.

"What's happening in here?!"

"We're singing."

Lidauer sized up the ragtag group in front of him. "Communist songs?" Fred doesn't think he knew the difference between Communists and Jews.

"No, folk songs."

"Well, sing then."

Berman turned around to his fellow prisoners and quietly said, "You're singing for your life." No one needed reminding.

The men began singing "By the Waters of Babylon," the melody bouncing off of the ceiling, echoing back to them, their voices coming

together in a well-rehearsed choir that brought tears to Lidauer's eyes.

"Good, good" he said, without thinking when the echo died down. Then realizing of whom he had approved, yelled out, "Dirty pig Jews!" turned, and stormed out. He continued to allow them to practice in the empty bath barrack at the end of the night.

Berman is the one man from Lípa who Fred is certain survived the War. After liberation, Berman eventually joined the Prague Opera House, where he sang and directed over the course of his life. When he died in 1995, obituaries would recognize him as "one of the last...great male soloists of the post-war era."[12]

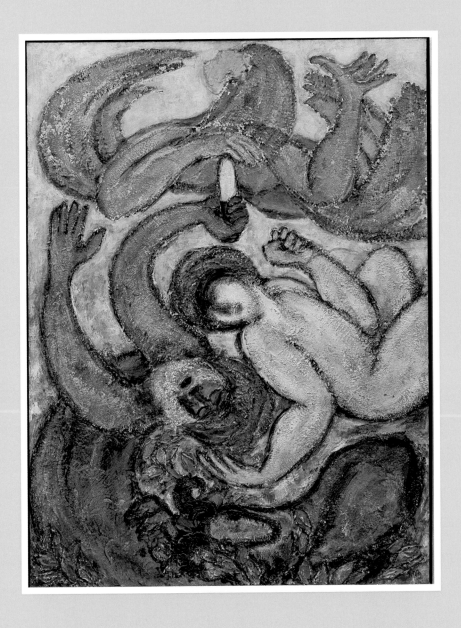

SECOND TESTING OF THE NAME, 1973
Acrylic and aggregates on canvas, 48 x 36 inches

As mentioned earlier, Fred explores the biblical story of the binding of Isaac (the Akeda) again and again over many years of his work. According to the story, Abraham is called by God to sacrifice his son Isaac. When Abraham has bound and prepared Isaac and is about to kill him, an angel intervenes and shows Abraham a ram to sacrifice instead. It is a story that Holocaust survivors often gravitate toward. In Elie Wiesel's book *Messengers of God* — a book about biblical tales, not Holocaust experiences — he calls this chapter, "The Sacrifice of Isaac, A Survivor's Story."

Of all the Biblical tales, the one about Isaac is perhaps the most timeless and most relevant to our generation. We have known Jews who, like Abraham, witnessed the death of their children; who, like Isaac, lived the Akeda in their flesh; and some who went mad when they saw their father disappear on the altar, with the altar, in a blazing fire whose flames reached in to the highest of heavens...

But the story does not end there. Isaac survived; he had no choice. He had to make something of his memories, his experience, in order to force us to hope.

Fred changes small details in his depiction of this story. In this piece, Abraham is pointing his knife at God and the angels, not at his son, and Isaac seems to be protecting the lamb in the bottom part of the image.

Fred says, "These things happened to me and my family. Why did this happen to the Jewish people? I'm trying to solve it visually by repeating the subject again and again. The Akedah shows up over and over as an angel, a ram's horn, a knife. All asking the same question over and over. Why did this happen to me and to my family?"

Chapter 6

Packed into the Camp (1943)

In March of 1943, one of the top SS members appeared in Lípa having heard that the local Gestapo was using the farm to produce extra food for themselves while rations were limited. He shut the camp down, and the prisoners were transported to what had been a large fairground in Prague then on to Terezin, as it was known in Czech, or Theresienstadt. Lípa would later be converted into a camp to send those in mixed marriages, people Fred would call a "German ethical gray area." To Fred, it was just a barked order one morning at dawn.

"Be lined up and ready to leave in three hours. Pack whatever you have."

They ran around their barracks, collecting their few possessions. When would they have the chance to acquire new gloves or shirts or jackets, after all? They were lined up and moved into a crowded passenger train

to a fairground filled with prisoners from the surrounding area being transported to a camp for the first time. What Fred most remembers about the fairground was the sudden abundance of water. It was March, and still chilly, but the men he was transported with hadn't had enough water for bathing in months. They washed, struggling to find skin under layers of dirt, then reveled in the availability of the water, playing and splashing each other in the cold. The assembled Prague Jews surrounding them were on their way to their first camp, and looked on the men from Lípa with disdain. Dirty. Flea- and lice-ridden. Playing like children in the fountains.

The fairground, now with everyone waiting for the train to transport them to a concentration camp, would have had a festive atmosphere in any other situation. Families were reunited, friends discovered loved ones still alive. The group from Lípa separated as they found people they had known before the war to travel with. Fred continued on alone.

The ride to Terezin was on a third-class train, guarded heavily by SS. The train left them at a railway station from which the walk to Terezin was long and difficult for many. It was at least two more years until a train station was built to transport prisoners directly into the camp. A strapping young man despite limited food for the last year, Fred was strong from years of hard labor. He carried his own backpack which contained the same things that had come with him to Lípa, though over a year worse for the wear.

As the elderly around him began buckling under their own weight, he took suitcases from them to carry as well. Eventually a mother with a small child who couldn't continue to hold him asked if she could put him on Fred's shoulders. By the time they arrived at the camp, over two miles

later, he looked more like a pack mule than a person.

In Terezin, Fred's transport was marched into processing, a large building where prisoners moved from one floor to another until their information was complete. They were stripped, searched, and given shoes and clothes again. Fred fortunately received his own well-fitting shoes back instead of someone else's; it's a stroke of good luck he credits with saving his life multiple times. Shoes will become an obsession over the course of Fred's lifetime, starting with this moment.

Hours later, when he completed the intake process, Fred stepped outside into the camp where he would spend the next year and a half of his life. There, outside the building, was a man looking much worse for the time they spent apart. Tired, underweight, and clearly ill, but standing there waiting to see his older son, was Jan.

They had never been physically affectionate as a family and Fred doesn't remember causing a scene with their reunion despite each man's joy. Did they even hug? He cannot remember. He only remembers asking questions about family members. And the distinct feeling of home that came with finding his father.

"Where is Tommy? And grandmother? Are they here?"

They had been there, yes. But only for three months in 1942. Grandmother, who overnight turned into an old lady when her husband died, became a woman of reverence again. Her barrack had put their trust in her and asked her to divvy food for them. Since then, she and Tommy had been transported elsewhere, and Jan hadn't heard from them in months.

They would have overlapped with my own great-great aunt and uncle in Terezin. In the letter to their children received after the war, my great-great uncle writes in July of 1942 that, "We have also received a request (order) that we should take such money that we still have available and buy into an old age home in Theresienstadt. Unfortunately, we do not have that much money available anymore." In August of 1942, they "received the order...to leave for Theresienstadt." Packed into the camp with tens of thousands of others, it's unlikely that they would have met Fred's grandmother or brother.

As I did to find this connection, Fred looked up his family's transport numbers many years later. His family all arrived together at Terezin July 6, 1942. On October 15, Tommy and his grandmother were transported together once more to the death camp Treblinka. They were two of 18,000 people sent from Terezin to Treblinka that fall.[13] Nobody from that transport survived. In March 1943, Terezin was already Fred's second camp. He assumed there was some kind of logic to how they were all moved around; it didn't occur to him that the others had been killed already.

Jan reported his own experience so far to his son. Through brutal shows of force over the course of October to December of 1941, the Nazis had terrorized the Jewish Religious Congregation of Prague into registering every Jew in the occupied territory. It became impossible to hide.[14] In December 1941, two months after Fred's deportation, Jan was shipped to Terezin, only the second transport sent there. Most of the men in his transport were young; at 48, Jan was one of the oldest. They were meant to build Terezin into a ghetto and prepare it for an influx of thousands of other Jews to follow. But shortly after arriving, Jan was moved again, this time to a coal mine in the nearby town of Kladno. An intellectual with

no experience in hard labor, his short stint in the coal mines did him no good and he quickly developed tuberculosis. He was returned to Terezin, where he was placed in a barrack that was vaguely separated from the general population so as to avoid spreading the infection. The barrack was across the camp from Fred's assigned bunk.

Terezin was a special camp, filled by then with people who had been at the top of their profession before the war. At various times, it held between 40,000-58,000 prisoners in part of the barracks, the entirety of which had been originally designed to hold 7,000 people. Some of the best doctors in Prague were there. But they had no medicine, nothing to work with, and little food. The distribution of the limited food provided had to be carefully allocated, with children getting the most, followed by those with the hardest labor jobs. Older men and women who were ill and not working were never well positioned to receive food. Women who had been nurses before the war began tried to keep their patients comfortable while they slowly starved to death in overcrowded barracks. Comfort was elusive with narrow bunks made of barely finished planks and mattresses of burlap sacks filled with straw. There was not enough space to walk between bunks. The only significant difference between the layout in Fred's barrack and the layout of Jan's was that the men Jan lived with were too weak to climb to a triple high bunk; their room was double or single bunks instead. Their few possessions were stored on a narrow shelf above their heads.

When describing Terezin, Fred swivels away from me towards his computer to find pictures to show me online. The first few pages of results are all empty barracks. As he scrolls through, he comments that the pictures didn't convey the feeling of what he experienced. The overcrowding was the worst part, but the photos were mainly of empty

bunks.

The Nazis had appointed those who had been active in the Jewish community before the war or who were early arrivals to manage unpleasant jobs, such as allocating food. As one of the early arrivals in Terezin, Jan was allowed to pick his roommates, 12 men, all with TB. They were all exceptionally well-educated experts in many fields, including former scientists, lawyers, physicists, manufacturers, high administrative officials, a judge, and authorities in other fields.

For these men, the fall to Terezin was a hard one. What little sanitation existed was totally inadequate. Once proud men had bed bugs and fleas, and no opportunity for personal grooming. When a member of the room died of tuberculosis or of complications caused by hunger and lack of water, another well-educated or interesting person suffering from an illness incurable in the current circumstances (which often could have been easily cured outside the camp walls) replaced him. They passed their days in talk and debate, discussing anything they could, current events whenever possible.

Fred snuck into the TB bunks almost daily to visit with his father; these visits gave the bunk a connection to the world outside their room. His father charged him with the difficult task of acquiring the Oberkommando der Wehrmacht Bericht, the official daily German war report, so that the men could stay informed of current events and would have something to guide their ongoing debates. In retrospect, with so little food or care, it's a wonder that Fred did not catch tuberculosis from these forays. Apparently even teenagers in concentration camps considered themselves invincible.

As the one who had gathered the others in the room, Jan appointed himself arbiter and chair. Any of them had the intellectual force to lead, but Jan took up the post as the first arrival. No subject was off limits, though politics and the war were often the focus. There were heated arguments about philosophy, ethics and aesthetics, history, and the arts. It was a meeting of sages of the day who may not have found one another outside Terezin.

Each day he made it in, the news, or what Fred could find of it, was thoroughly reviewed before the men returned to their conversation. Though subjects varied, one of Fred's favorites was the question of what to do about Germany after the war. They all agreed that Germany would certainly be defeated, likely soon. Perhaps it was this certainty that would get Fred up and out to work on his darkest days, and in the difficult times ahead.

Jan and his bunkmates spent their time planning not only their own futures, but the futures of nations; they formed a rudimentary imagined United Nations: Each man in the room represented and spoke for one of the allied nations — USA, England, France, Russia, Canada, and so on down the list, and they included countries still occupied by Nazis such as Czechoslovakia, Poland, and the Netherlands. Each man was responsible for proposing a settlement favorable to the nation he had been assigned to represent.

Proposals included the division of Germany into 10 occupied territories, into states as they existed early in the 19th century under Napoleon, or into the same 300 or so units following the treaty of Westphalia of 1648. The debates would go on for days, each man vying for a turn. Similar debates were happening outside the camp walls. By this time,

exiled members of the Czech government who were living in London were already calling for their home country to expel all ethnic-Germans from Eastern Europe after the end of the war as punishment for their presumed complicity in Nazi actions.[15]

One afternoon during Fred's visit, one of the men threw up his hands and declared that Germany may retain its borders of 1932 with one strictly enforced condition: "All metal — every last scrap — will be collected and delivered to the Allies. No use of any metal will be permitted in the future. Send Germany back to the stone age!" He managed to keep a straight face for a moment, then everyone in the room laughed, and the debate continued.

The man representing the Soviet Union insisted that, "The USSR has sustained much heavier military casualties than European countries. With all of the damage we've suffered, we deserve extra votes." Not that it mattered of course, he insisted as the only communist representative in the group that there had to be unanimity in any major decision about Germany.

During visits to his father's barracks, Fred also found out about his father's new companion, a nurse who was helping to care for the tuberculosis patients. Years later, in searching through archives for information about his family, Fred discovered the two had married. "People married thinking there was some benefit to it," Fred says. Maybe there was. Jan and his new wife had adjacent transport numbers on the trip to their final death camp, which may have kept up the illusion that the Nazis would not split up families; if they were married, they believed they would be kept together.

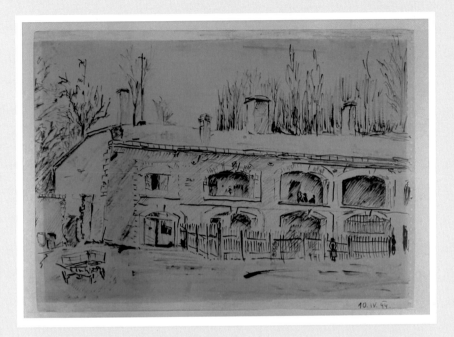

INDIA INK FROM TEREZIN

The ability to look back at works he created while interned is critical for Fred. To him, art is where history is made. "I say, 'Tell me a dozen businessmen of the year 1650,' and you will not be able to tell me one. But I can tell you a poet, and a dozen painters, and Johann Sebastian Bach."[16]

When Fred and Rebecca, his second wife and the true love of his life, were married, they took a honeymoon to Israel. They had heard there was a kibbutz that had collected documents from the war. They arrived at Kibbutz Givat Haim Ihud and told them they were looking for pictures from Terezin. The curator did not know specifically what was in storage but allowed Fred and Rebecca to look through the boxes. In the middle of a file of unidentified art, they found six of Fred's works. Over his time in Terezin, Fred created dozens of works and this picture

is one of the few pieces that survived. It's a building he passed often, used to hold the mentally disturbed.

Chapter 7

Sketching or Working (1943)

In Terezin, Fred was assigned to a roving group of internal fixers, called hundertschaft, groups of 100 men and women who were deployed for jobs ranging from fixing a leaky roof to building a new road, and generally serving as problem solvers. It meant he was moved around the camp frequently; he saw more of the settlement than many of his fellow prisoners. The overcrowding made it hard to get around.

"Imagine walking around Times Square on New Year's Eve, but without the exuberance," says Fred. As a result, it took a long time to get anywhere, even when there was nowhere to go. There were long lines for food, which often consisted only of the chicory coffee Fred had grown used to in Lípa for breakfast. This was followed by a full day of hard work, interrupted for a few minutes by stale bread, more work, and eventually a thin cabbage soup at the end of the day.

Many in the camp had more intellectual jobs that built on their expertise coming in. Among those jobs was the Nazi drafting office run by Bedrich Fritta. The drafting office created both signage for the camps and propaganda posters for the Nazis to distribute. Filled with Jews who had made their living as artists before the war, the Terezin drafting office made art materials slightly more accessible. Occasionally, one of the artists drawing Nazi propaganda would steal art materials to use himself or to pass on to others who needed to create art to survive. According to Fred, it was known as "something of an honor to steal from the Nazis." Through a friend in the drafting office, Fred wound up with a notepad and a little bit of ink.

On one of the first details he was on, Fred was digging ditches. A sudden rainstorm filled the ditches with water and they were unable to keep digging until it passed. While they waited out the storm under a tree, Fred found a small piece of paper and a pencil in his pocket. He began sketching the roads and trees around him. He pulled the landscape back under his own control in a world where he had no control at all.

Fred was 20 in Terezin. Had he been a young child, he would have received some sort of formal art education from one of the ghetto teachers, Fridl. The children understood that they should learn, but that the moment an SS Guard came by, whatever resources they had needed to be hidden under the bed or behind a bunk. As an adult, if Fred wanted to learn, he too would have to hide, but in addition, he would have to seek out teachers. As in Lípa, he had access to great minds and great artists whom he could ask for advice. He found an architect, Frantisek Relenka, who taught Fred how to use the ink he had been given, and together they whittled a stick as a "brush," something that would allow thinner and thicker lines or lighter and darker grays. He

drew what he saw: walls, roads, trees sometimes. He recalls that many of these drawings were about lines. There were lines everywhere in Terezin: lines for food, lines for the bathroom, lines for water, and for work.

Fred had a huge amount of respect for Fritta, who ran the drafting office; Fred still speaks of him with awe. It took Fred a long time to work up the courage to ask Fritta for feedback on his work. As Fritta paged through his work he said "terrible," and as he turned the page, "awful." Fred felt himself grow smaller with each passing page. When Fritta handed the sketches back to him he said, "These are fine work, but if you're caught with them, you're dead."

The warning was one Fritta never took himself. He was trained in German expressionism, and when he was not under surveillance and forced to create propaganda, he used whatever supplies he could find to create images of what was really happening around him. People were starving to death, being shot, dying everywhere. He drew reality. When one of his pieces was found, he was taken to the small fortress on the edge of Terezin, where the Nazis beat him so mercilessly that he died in transit to Auschwitz, where he would have otherwise been gassed.

To avoid this fate, Fred signed his name BX (B for Bederich, his Czech name and X as a sideways T) hoping that if he was ever found with his work, he could deny being the artist. He kept the works safe in a tin box he had found. He dug out a stone in the floor of his bunk and hid the tin box inside.

Unlike Fritta who was able to pocket supplies when the guards were turned away, Fred had to count on others to steal ink for him and he ran

out quickly. His ingenuity never ran dry, though. Fred searched for and found a sofer, a specially-trained Torah scribe, thinking, "He will know about ink." The sofer told Fred that if he had the carbon scraped from the bottom of the pots in the kitchen, they would be able to make ink.

The challenge of getting into the kitchen gave Fred something to focus on. After dark, Fred entered the kitchen under the guise of doing work around the camp to scrape the pots; he brought the carbon to the sofer. According to Fred, the sofer "mixed it with a little bit of this and a little bit of that and gave me back a jar of ink." Fred continued drawing. Only a few of those works survive today, recovered by Fred and Rebecca in Israel.

Fred's art served two purposes: one was to give him a measure of control over something, in this case, the blank sheet of paper. Still seeing light and dark as he had as a child in the art classes he failed, he found that putting shape and color to a previously white space made him feel that he could manage what was going on around him. He had total freedom, nobody setting rules to his art, no coercion, money, or political order; just a piece of paper waiting for a sketch. The other purpose was simply to record what was going on around him. What it felt like to be inside a fence and constantly afraid.

When not sketching or working, Fred took advantage of the thousands of Jewish intellectuals who were penned in with him. In a sense, they had been equalized; whether you were rich or poor before the war, no matter how much education you had had, you were now sleeping in a triple bunk with bed bugs and lice. This had never been a single community, and the tens of thousands of them did their best to form sub-communities. Their schedules gave them time between when it got dark

and a camp-wide curfew at 8:00pm. Fred heard poets share their work, music by fellow prisoners, great rabbis speak. A few minutes before 8:00, everyone scattered to be back in the barracks by curfew: racing both the clock and each other to not be caught out after dark.

Fred was in Terezin when the Red Cross visited — their infamous single visit to a concentration camp during WWII on June 23, 1944. Fred was part of a team that readied the camp. Over the course of the months before the Red Cross's arrival, fake accommodations were built, barracks were renovated, flowers were planted, and thousands of people were shipped out to other labor or death camps so the Red Cross would not see the overcrowding. It is likely in anticipation of this visit that members of my own family in Terezin were killed.

The SS Commanders established the route for the visit, and staged performances for the Red Cross along the way. Instruments were brought in for a concert and removed promptly at the end of the visit. Fred was part of a group that painted houses and walls in anticipation of the Red Cross arrival. They could not do the job poorly and risk being punished, deported, or killed. So, in their attempt to alert the Red Cross to how dire the situation was, they painted everything perfectly. The Red Cross would have to realize that it was done for their visit; no wall can stay perfectly white for long. They would have to know it was fake.

"The Jewish administration, under duress from the Germans, treated the visiting delegation to the trial of a person 'charged' with theft, which 'just happened' to be taking place; a soccer game in the camp square complete with cheering crowds; and a performance of the children's opera Brundibár, performed in a community hall built specifically for this occasion."[17] A child was made to run up to one of the Nazi guards

during the tour and ask for his "daily chocolate."[18]

"After the war, we found that the three 'international' Red Cross visitors were a German, a Swiss and a Dane. The German was a Nazi, the Swiss was a sympathizer. The Dane saw clearly that it was all fakery, but there were still 500 Danish prisoners in Terezin, and he did not want to endanger them, so he kept his mouth shut," says Fred. Whether the Red Cross was taken in by the fakery or was protecting the few people they were able to, they did not step in to investigate further after the visit to Terezin.

The Nazis used the newly cleaned-up camp to make a propaganda video, featuring happy children, whitewashed walls, and another staged soccer game. The film was never used, despite the work that went into it. Decades later, Fred would be horrified to find that the Brooklyn Museum was planning to show the footage that was found unedited. He called the curator, who invited him to narrate the film as it was shown. At the top corner of the screen during the soccer game, Fred points out that you can see Nazi guards ensuring that the crowd smiled and cheered throughout filming. The assumption among prisoners was that if you broke character, you would be killed along with all those around you.

LASTING DRIFT, 2015
Donated to United States Holocaust Memorial Museum
Acrylic and aggregate on canvas, 24 x 48 inches

While he was in Terezin, Fred would sketch exactly what he saw when he had the opportunity, but his paintings after liberation are often more expressive and abstract. The realism of this piece is uncommonly painful among his later work. It's perhaps one of the most purely representational pieces we look at together; the chimney belching smoke in the background and small sticks incorporated to represent bones of those not buried deeply enough.

Chapter 8

A New Form of Courtship (1943)

Each time a transport arrived in Terezin, Fred would try to find the list of who had been on the train in the same way his father had found him. Though not easy, it was possible to find someone who had access to the registry and ask about old friends and schoolmates. In this way, Fred found out Stella arrived in Terezin in July of 1943, four months after Fred, with her sister Eva and the rest of the Horner family.

Fred tells me, "There was a saying in Terezin, 'Everything in Terezin is made on a bed, except love, that's made behind the door.'"

When they reconnected in Terezin, Stella and Fred found themselves once again two teenagers in love. Stella had been dating another man while Fred was in Lípa. He was older, a businessman, and much more experienced than either Stella or Fred. In Terezin, this man began

drifting between girlfriends and Stella considered herself single again.

Stella and Fred began a new form of courtship, distinct from their formal months of dating in Prague, which had consisted of sneaking out without yellow stars and kissing on street corners. During the hours after work ended but before they needed to return to their bunks, the two would meet clandestinely or in each other's barracks. Fred's job allowed him to move around the camp less impeded than others, and he found quiet places the two of them could be alone together. The barracks were overcrowded and dirty. Still (or perhaps because), they were where most people spent their entire day. There was little else to do, and when it got cold, the overcrowding kept the barracks warmer than the rest of the camp.

With both families imprisoned together, the formalities of young courtship fell away. Stella's parents did not have the same certainty as Fred's that they would survive; to worry about keeping their daughter "pure" would have meant that they truly believed she would live, marry, and form a life in the future. During the time they overlapped, Jan was in the TB bunk, far from his son and his girlfriend. Besides being prisoners of the Nazis, Fred and Stella essentially became unsupervised teenagers, glad just to find comfort in each other's arms.

Men and women were allowed into each other's barracks during the day. The men were very aware of one another's needs and girlfriends, and when a man and a woman were in a triple bunk, the man would put a blanket around the bunk, the other two in the triple would leave, and the rest of the people in the barrack carefully stayed away until they came out. Other times, prisoners would pull a door open and slip into the hidden triangle of space behind it, where there was privacy for a few

minutes. Everyone knew better than to move an open door during the day.

Fred and Stella looked for privacy wherever they could find it. Fred found a storage facility for straw and snuck himself and Stella inside. There was at least some degree of privacy there, more so than wrapped in a blanket on a triple bunk or hidden behind the door in the barracks. Stella had lost her virginity to her older boyfriend before arriving in Terezin, but it was Fred's first time. Their bodies were both wasting away, starved and scarred as they were. And yet they found each other beautiful in those moments. They finished and held each other, whispering, smiling together, finding passion and warmth. They held hope in each other's arms.

In retrospect, Fred can't believe how stupid it was. If Stella had become pregnant, she would have been killed, they knew that even then. What use is a slave who can't work? But by the time they found each other, the terror, work, and starvation had long put an end to Stella's periods. And at 20 years old, once you get the hang of it, sex comes easily, quickly, and frequently. After the private and passionate first time, they started meeting for trysts at the end of the workday before returning to their bunks.

Even in the moments of hope they found together, they could not hide from the reality they faced. They would whisper plans to each other of what to do when their orders came. Thousands of people were being shipped out in cattle cars. Friends and neighbors were disappearing at an alarming rate. There was no communication at all by then, so they did not know what happened to their fellow prisoners after they were routinely loaded onto trains. They did not know there were only death

camps at the end of each ride. Fred and Stella only knew to expect to be separated any day.

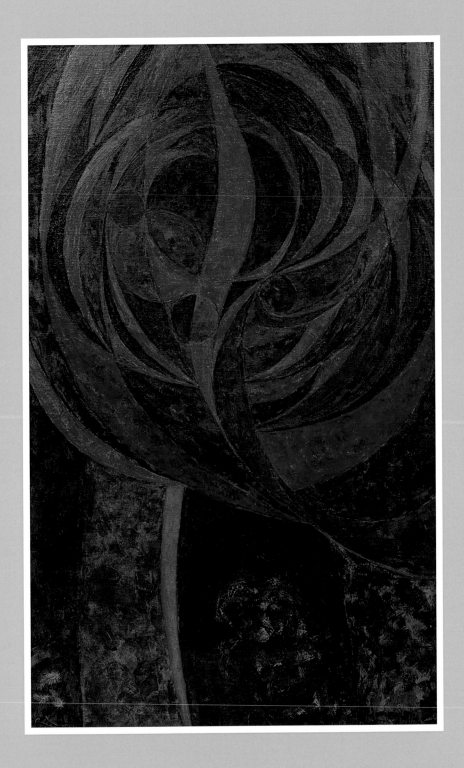

FACE TO FACE, 1984
Acrylic and aggregate on canvas, 48 x 30 inches

This piece utilizes imagery seen throughout much of Fred's work. The black and red flames allude to the classical Jewish imagery of a menorah. Circles can be seen throughout the canvas, filled with both the hope and pain they signify. At the bottom, a couple embraces in the midst of the chaos, while on the left-hand side, another face, made of feathers and pins, looks on.

Chapter 9

Ash and Smoke (1944)

A s they expected, Fred was eventually given a slip of paper saying that he was to report for transport the next morning. It was his turn. He knew he was young and, though emaciated, still able-bodied. He expected to be sent somewhere new that needed ditch diggers. He snuck into his father's barrack to say goodbye.

He showed his father the slip of paper, and they hugged briefly.

"Auf wiedersehen," Jan said to Fred, literally translated, "Until we see each other again." Fred left certain that it was true, that the war would end soon, and they would be reunited shortly. If his father knew that this would be the last time they saw each other, the last time they embraced, he hid it well, allowing his son the optimism that would help him survive what was to come. There were no tears from either of them.

From there, Fred went back to his own bunk, where he retrieved his hidden box of drawings. He gave the box to Stella and asked her to hide it and keep it safe. It made its way from hand to hand, hiding spot to hiding spot until, as mentioned earlier, Fred and Rebecca found the few surviving pieces in Israel decades later. Fred told Stella to find the super of his family's apartment in Prague when the war ended; they would all check in with her and she would know where everyone was so they could find each other again.

The next morning, he joined the group that was being counted and put on a train to Auschwitz. No longer treated to overcrowded third-class trains built for people, they were forced to stand together in cattle cars. The ride was longer and more difficult than the others. There was no food, no water, and no space. Through cracks, the people in Fred's car used the sun and moon to determine they were going north, then later, east. But to where, they had no idea.

This was the worst time for Fred. Usually when he speaks about his experiences, he says simply that there are many places where one can read about the horrors of Auschwitz, but his account will not be one of them. Knowing this, I offered to let him skip these weeks of his life, but he continued. It was also the only time when we spoke that Fred closed off his body, crossing his arms over his chest and leaning away from me.

The train stopped in the middle of the night. The doors flew open. Guards with dogs were screaming at the prisoners. "Leave everything and get out!"

The guards screamed Fred and the others emerging from his car into a single long line. They saw chimneys belching fire and smoke. It was loud.

The Nazis never spoke, they only yelled or screamed. They did not see people in front of them, but animals to be dealt with. There was a stench Fred did not recognize but which made him sick. Most of all, there was fear. Children screamed as they were separated from their parents. Other prisoners have described music playing when they arrived.[19] The Nazi guards found the sound of people being murdered in gas chambers too upsetting, so they rounded up Jewish prisoners who were musicians. They played jaunty parade music all day to drown out the sounds of death all around them. The guards told Fred and the other prisoners that they were in Auschwitz-Birkenau, but since communication had been cut off for years, nobody knew what that meant. Left, left, left, right, left, left... Few people survived the initial selection upon arriving in Auschwitz.

Within hours of being sorted with other prisoners, Fred understood how lucky he was that he was sent to the right. It didn't take him long to realize the smell was that of burning flesh and hair. People's bodies being turned into ash and smoke.

Fred was sent with the other remaining prisoners to strip and leave his clothing behind. They were given striped pajamas. Once again, Fred was one of the few who managed to get his own shoes back. He had been wearing them for years already, and the importance of this crucial coincidence cannot be overestimated. When he was marched, moved, or forced to stand for hours on end, usable, well-fitting boots were the difference between life and death.

For the first time, Fred began to consider that he may not survive the war. He stopped thinking that he might live to see freedom, and simply tried to live another 24 hours. A happy accident could save his life for a

day, a random mishap would be immediate death. The smell of burning flesh and the acrid smoke that filled the air around him became the only smell he could remember.

He was sent into a section of Auschwitz called Zigeunerlager. It had been a Gypsy camp before the Gypsies were all murdered.

The first thing Fred and the few who had survived from his transport tried to do was find out where they were and what was going on. Each camp within Auschwitz-Birkenau had its own set of wires and guards in towers. The camp order came into focus: wake at dawn, stand in line to find the kitchen is out of soup, stand in rows and be counted. There were no jobs the way there had been in Terezin. There was nothing to do but starve. Fred could easily count his ribs.

When Fred reflects on Auschwitz, he understands how the Nazis could reduce Jews in their eyes to animals. They bore little resemblance to functioning human beings. The people the Nazis saw walked in the mud. They were freezing. They were starving. Fred recounts that in the barracks all of a sudden people would start running, so you would start running. You may not know why the people around you were running, but you assumed there was a good reason, and you took off with them. The way a flock of birds might take off in an instant all together for reasons an outsider doesn't understand. It is a herd mentality. Except the furthest one could go was from one barrack to another.

Dirt. Degradation. Yet the prisoners continued to go out of their way to be polite to each other, calling one another "Sir," or "Mister." Their own small refusals to become the animals their captors saw. There were no longer possessions. On the rare occasion that a prisoner managed to find

a handful of potatoes, he hid them in his cap. There was a very small amount of water to drink, though Fred does not remember where it came from. Proper bathrooms or showers were nonexistent for the prisoners.

Unimaginably, the barracks were even more crowded than in Terezin, with prisoners now stacked four high. At night, the men were not allowed out to use the holes that were considered bathrooms during the day. Instead, a steel drum was left in the back of each barrack. They were not allowed out to empty it. It would fill and overflow quickly. There was filth everywhere.

They were guarded by Kapos, prisoners given extra food and a separate sleeping accommodation in exchange for showing extreme brutality towards the people they were guarding. Beatings were constant, and those beaten often fell over and simply froze to death on the ground. In Fred's camp, the Kapos were convicted criminals whom the Nazis believed would be particularly brutal. Each had young boys they kept as slaves and at night the prisoners could hear the boys screaming and crying.

A few weeks after arriving, there was another selection of prisoners to be loaded onto trains in the Zigeunerlager. Fred didn't know if those put on the train would be gassed or sent to a labor camp. He watched as the Kapos sorted their boys into the transport. There was a quick whispered discussion with those around him. They seemed so attached to some of their little boys. Were they doing this in love to get them out of this hell? Or were they bored and sent them off to die at another's hand while choosing other children as replacements? The prisoners gambled that those on the transport were going someplace better, and vied to get on the train, pushing their way into the line. Fred managed to get on.

It was another long, crowded, unfathomable train ride. A train jam-packed. No seats, no standing room, no water, no toilets. The cattle cars were built to have enough air circulating for about eight cows. The small windows at the top were not enough to circulate air among the hundreds of people crammed inside. Those who died were packed in so tightly, their bodies remained standing.

The prisoners could tell from the sun that they were going south. When the train stood still for a long time, Fred recognized they were outside Vienna by the remnants of the giant Ferris wheel he could see through the slat of window.

When he finishes telling me about Auschwitz, Fred unfolds his arms and clasps his hands in front of him. We stare at each other blankly. Fred seems unsteady and I try to hide that I'm on the verge of tears. We decide to end early that day, and I leave to take the train home. It is a beautiful day outside and Fred asks to walk me the mile to the train. He tries to make conversation, asking about my family, my boyfriend. I am almost unable to reply. It seems impossible that the sun should be shining, that my mom is waiting for me at home in case I want to join her at the beach. Fred keeps putting one foot in front of the other. The next morning, he tells me that he walked for another hour after dropping me off then had nightmares that night. Instead of telling him that I did too, I try to apologize for making him relive what he usually refuses to speak about. He waves me off.

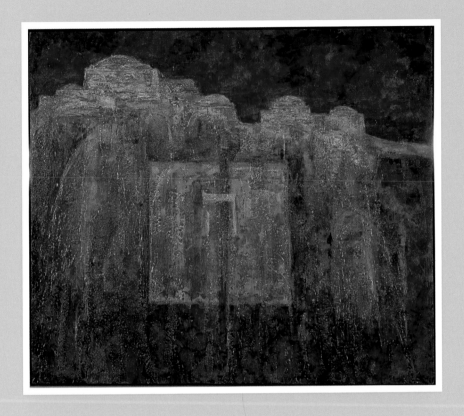

THE NAME ON FIRE, 1982
Acrylic on canvas, 40 x 48 inches
Collection of the Yad Vashem Art Museum, Jerusalem
Gift of the Artist
Photo © Yad Vashem Art Museum, Jerusalem

The inside of the ovens haunts Fred. The way he imagines the
doors of the Auschwitz ovens — opening to obliterate the
bodies of those whose lives were already taken — is another theme
throughout his work. In this, one of his seminal pieces, now in
Yad Vashem in Jerusalem, he paints God's name in Hebrew letters

going up in flames inside the oven, a sacrifice at an altar nobody chose. The Temple Mount can be seen in rough outline in the background.

Fred did not consider himself religious before the war, so the idea of God never provided solace. He questions the stories of those who claimed to stay religious in the camps; how can you believe in a God that would do this to people?

In Auschwitz, there were no windows in the barracks, just an overhead opening. Fred would look from his 4-tier bunk through the gap between the walls and the roof and see flames and smoke overhead, the difference between the sleeping and waking nightmare almost impossible to distinguish.

Chapter 10

To Keep Marching (1944-1945)

The train passed through the Alps, and when it arrived and the doors opened, the men inside fell out, along with the bodies of those who died along the way. They were breathing in fresh air for the first time in days. They were counted and marched to a nearby labor camp called Kaufering. Kaufering housed about 40,000 Jews. By the end of the war 35,000 of them had frozen, starved, or been beaten to death. It was a labor camp, after all, not a death camp.

Germany was trying to construct underground factories to meet the demand for weapons in the war. They needed factories that couldn't be easily bombed by Allied forces, and they had chosen this region of the Alps because the ground cover was already so thick. The Nazis imported the men on Fred's train as additional slave labor to clear out places under the mountains and in caves to make room for the subterranean

factories. [20]

The men marched to Kaufering Camp 4 to huts that would become their sleeping quarters. The Nazis were afraid of the camp being seen by Allied planes, so rather than full tents, prisoners were forced to dig long trenches about three yards wide and 18 inches deep. Three tent poles kept a tarp over their heads, and a single window at either end allowed in minimal light and air. From above, they would have looked like the tops of long, thin, houses with triangular roofs. Inside, there was a stove in the center of the hut that was meant for heat, though it wasn't much help. The huts were covered in mud and dirt to disguise them to planes flying overhead. The higher-quality huts had wood flooring, but most did not. The men had to enter hunched over, and only next to the center pole was it possible to stand up straight. Each hut slept 50-100 men. When the snow melted and water drained down, they slept in mud.

Those who came in with striped pajamas kept them. Others were issued a worn set. Everyone received a thin wool cap, a spoon, and shoes. Fred's own shoes, worn for over three years of hard labor, were taken away. The ones he was issued had wooden soles with a canvas top. Low quality, but at least they were the right size, and they held up over the many hours, days, weeks, and months of marching ahead of him. If shoes gave out, it could easily mean death.

The guards woke the prisoners for count. They stood outside, a form of torture, in 10 rows of 10 men. The guards did not care if they were alive or dead, just that they had the same number of bodies as the previous count.

After count, they were each allotted one cup of the black chicory blend

"coffee" Fred was familiar with from other camps. With so little water available, access to any boiled clean water remained hugely important. There were no showers, and certainly no soap. For Fred, cleanliness had ended long ago. He had had lice for years, but it started to feel that the lice had him; that they were the only thing keeping his body together, even as they bit at his shoulders, and burrowed into his legs. He still has scars on his shoulders to this day. X-rays show notches on his shin bones where the lice burrowed all the way down to the bone and bit off pieces.

Each day the prisoners were marched to the space they would be clearing. If on the way a man stumbled or fell, the guards beat him. They were bored and kicking Jews was good entertainment. There was a sense of community among the Jews, even between those who didn't personally get along. If they were to survive, they would have to do so together, so if someone stumbled in front of you, you didn't step over him, you caught him. Placed him back on his feet. Pushed him forward to keep marching.

Those who made it to the end of the march each day were counted again, and sent inside the caves to begin work. Count, coffee, marching, and second count took almost two hours and was immediately followed by a 12-hour shift. There was heavy machinery digging up the dirt, rocks, and soil from under the mountain, but they didn't have anything to move the debris out of the way; the prisoners were responsible for carrying it wherever it needed to go. They worked for 5-6 hours, then had a short break, during which small pieces of bread were handed out to each prisoner. Then another 5-6 hours of dragging heavy bags of cement, rocks, and sand around the caverns. After they were counted and marched back, there would be a small amount of lukewarm broth for each person, sometimes with a bit of potato or pasta in it.

The excavations went on 24 hours a day. When Fred first arrived at Kaufering, he was put on a nighttime work detail. He knew after only a few days that being counted and marched in the dark, along with working nights in this cavern would kill him in no time. He was certain he needed to be placed on a daytime detail to survive. At least there would be a few minutes of light each day while he marched. He pretended he was ill one day before the first count, forgoing food for at least two days completely, and managed somehow to get himself reassigned to the daytime shift.

There was no space for art here, no creativity. But even in the midst of the squalor they were forced to live in, Fred and the other prisoners continued teaching each other. It hearkened back to Lipa, in many ways. You tell me what you know, I will tell you what I know. They could only stay awake for half an hour or so a night after work, but the men in Fred's hut would share a little bit of knowledge with each other. "One person would talk, and the others would listen. By then it was very, very clear to me…" that teaching meant "'I'll need it. I'm going to survive, and I'll need that information.' Learning became a mode, a survival mechanism — one of them — but I think an emotionally important one, because somehow we said to each other, publicly, 'We are going to survive.'"[21] Knowing that there would be a chance to teach or learn something was a form of mental protection.

A particularly vicious guard made sport of punching the prisoners in the head during count. He laughed when they fell over from his fist, then kicked them a few times. Some would stand again eventually; some would die on the ground. But when the men shrunk away from the fist about to connect with their skull, he would beat them mercilessly, often killing them in the process. One count, it was Fred's turn for the beating,

and as he watched the curled fist come closer, he instinctively took a step towards it instead of away. His forehead collided with the guard's forearm, and though he stumbled backward and fell, the pain was duller, and after a loud curse and a few swift kicks, the guard walked off.

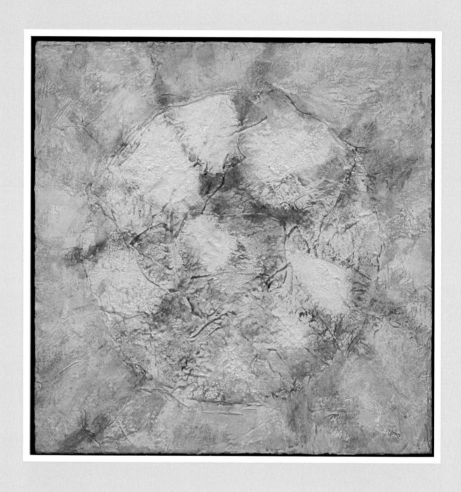

MANDALA MOVING, 1974
Acrylic on canvas, 24 x 24 inches

LINE TOWARD CREMATORIUM, 1960s

Ink on paper, 11.5 x 8.26 inches

Circles are a major theme throughout Fred's art. He explains that some circles are about wholeness: the entire world together, the womb, and protection. Nothing can get in. There is safety inside. In other cases, circles are enclosures. There is nowhere to go. In Line Toward Crematorium, people are unable to escape the circle, which serves as an enclosure taking them to the ovens.

Fred feels a tremendous responsibility to share what happened to him and says yes to almost all interviews. One day, I join him for a follow-up interview for a City University of New York news show, and the interviewer asks Fred to talk about the significance of circles. Fred feels strongly that once art is in the world, it is for the viewers to interpret themselves. When I press him too much on artistic interpretations, he often gets frustrated. In this case, the interviewer and her boss disagreed on Fred's use of circles, so she asks Fred over and over again, "Are circles good sometimes and bad other times or can they be both good and bad at the same time?" Fred resolutely refuses to answer. Ultimately, Fred believes art is always about the viewer, and the viewer's own interpretation. When I look at these two pieces next to each other, I wonder, is the circle in Mandala Moving good, bad, or both at the same time?

Chapter 11

Shuffling Skeletons (April 1945)

I n 1945, having survived almost six months in Kaufering, Fred was struck as part of an epidemic of typhus in the camp, which the Nazis wanted to contain, and he was moved to a separate sub-camp. Slaves who could not work were useless, but the influx of prisoners was slowing, and they could less afford to waste lives than they had earlier in the war. He was not sure how long it had been since he worked, but he knew he hadn't eaten since then. From their hut, Fred and his fellow prisoners could hear the exchange of fire, of heavy artillery. They could tell that the front was advancing. Patton's third army was slowly forcing the Nazis down to Bavaria. Auschwitz had been liberated almost four months before and other camps were being freed as well. Needing slave labor, the Nazis pushed those in Kaufering towards the Alps, where they would continue their work. Death marches began. Shuffling skeletons were dropping dead as they were forced to walk miles in the snow in worn out shoes or no shoes at all.

Fred was still sick in the tents of Kaufering Camp 4 when it was evacuated. The SS officers appeared at the door of his earthen hut and ordered all of the men out into the cold. It was the middle of the night. Fred stood as best he could, and left the hut, but he stumbled, and for a moment, thought he could not walk. Men around him were being shot as they fell, and he believed this was it. After everything he had managed to live through, he would die on the frozen, snowy ground in this moment.

A Nazi officer put his pistol under Fred's arm and shouted "Auf!" "On." Putting a little weight on the gun under his arm, Fred managed to get up once more. It was the first time a Nazi would save his life that night, but not the last. Why the guard chose to pick Fred up instead of shooting him, he will never know. It was not humanity. In Kaufering 4, hundreds of prisoners died when the SS guards used flamethrowers to burn the barracks, wanting to leave no trace behind. Those too sick or weak to move were stuck inside and burned alive. Fred kept walking. Towers of the guardhouse illuminated what was around him. People were screaming, dogs were barking. He could barely put one foot in front of the other. But he saw a piece of iron on the ground and for some instinctive reason, without stopping or thinking, he bent down, scooped it up and managed to right himself before the SS noticed.

Fred slowed toward the back and made eye contact with a friend, Tommy Mandl, who understood without speaking that he should slow down too. Fred and Tommy tried to be the last ones into the car. They whispered a plan to each other, not that anyone else could hear over the noise. Once in the train car, they would jam the iron piece through the wall to make a hole and create some airflow. No matter the cold, when they were all packed in, their body heat would keep them warm. They were last into the car, but for some reason, rather than hold onto the iron

to complete the plan, when the doors started to close, Fred jammed the metal in the bottom, leaving a sliver of space. As the SS guards yelled at them and tried to pull the door closed, the train started moving.

It was the middle of the night, dark and snowy. American fighter planes caught sight of the train and started dropping bombs. The Americans, of course, could not know Jewish prisoners were the only ones inside. They had barely started moving when the train slowed almost to a stop. Once again, simply by instinct, Fred threw Tommy out through the opening they had created in the door then jumped out after him. They landed in a deep snowbank and rolled behind some trees at the edge of a forest. Other inmates who jumped out after them were shot and killed by those on the fighter planes.

"We can't lie here in the snow," Tommy said, "We'll freeze to death."

"If we move, the planes will see us, and they'll shoot us."

"Can we go further into the forest?"

They looked behind them. They didn't know how deep the forest was, or where within it they would find food or shelter.

In front of them was the floodplain of the Lech River and in the middle of that, a highway. They knew the area from having been moved around the camps so much and perhaps either from their lessons together, which would have included geography, or from subconsciously planning escape routes during their months imprisoned. If they could get over the road to the floodplain, they would not be seen.

"If we can find a haystack," Fred reasoned, "we can hide in there until

the fighting is over. It will at least be warmer than out here."

Leaning on one another for support, Tommy and Fred managed to get each other to their feet.

They skirted around the edge of the floodplain trying not to be seen. When they got to the other side, they were caught by two young SS troops, Fred estimates they were 16 or 17 years old, under the command of an older guard. The soldiers ordered the two Jews to walk ahead of them. Tommy and Fred could not keep up with their pace, and the boys wanted to shoot them.

The older soldier barked at them, "I'm in charge. I didn't give an order to shoot. Load them onto that cart and we'll deliver them somewhere." He was the second Nazi to save Fred's life that night, for no apparent reason. Fred and Tommy were put in a hand cart and the guards wheeled them back towards the camp. When they reached Camp 1, chaos reigned, and Fred and Tommy slipped away unnoticed. The front lines were getting closer; their only hope was to live through the battle that was about to ensue.

Fred had been in Camp 1 and knew his way around. He and Tommy split up, each hiding inside a cement base surrounded by soil. He hoped that the anti-aircraft missiles pointed at where he was hiding were not manned, and if they were, that they wouldn't be used to shoot into the camp.

In the cement base, freezing, wet, sick, and listening to the war rage around him, Fred returned to one of his favorite fantasies from the last four years: drinking something hot, anything. Nothing had been more

than lukewarm in years. If only he could eat something hot...

At some point, he passed out. It was days since he had eaten or had water. He hadn't slept. He had no idea how long he was hidden there while the fighting went on around him. It could have been just hours or maybe days. But it was daylight when he awoke and heard noises that sounded different than those of the advancing front. He peeked out of the cement basin and saw soldiers walking through the camp. They weren't German, but he wasn't sure what they were. They had big helmets on. Maybe Italians? He heard them speaking to each other and made out that it sounded like English. It didn't make sense, because in pictures of American soldiers from WWI, they were always wearing small, flat hats. He felt sure they were with the Allies, whoever they were. He stirred in the cement basin and tried to pull himself out. He was too weak, but he managed to make enough noise to be noticed. The American soldiers in front of him reached in and pulled him out of the rubble, then supported him when they found he could not stand on his feet. It was April 27, 1945. Fred was liberated.

The soldiers asked what he wanted and he asked for what he had fantasized about: hot soup, which he was given. The soldiers brought him to the makeshift hospital nearby to bathe and rest. He was put in one of the largest rooms and as the caretakers began to leave, he came to his senses.

"Wait! There is someone else. He was hiding with me," Fred said, then described where he had last seen Tommy.

A few hours later, Tommy was brought to his room on a stretcher. As far as Fred knows, they were the only two to survive from that train. Fred's

ability to speak English earned him special status. He had the best room in the place, a king suite, and the soldiers allowed him and Tommy to stay in the room alone. Later, they met a Dutch man they liked, and he joined them. Slowly, Fred began to paint again, to walk, to gain weight and strength. After a few short months of rehabilitation, he was loaded onto a stretcher and deposited on a train to Prague.

UNTITLED (Landscape), 1958
Oil on canvas, 15 x 24 inches

Landscapes were among the first pieces Fred painted with the watercolors missionaries brought him in the hospital after his liberation. He wanted to paint his future. And yet each time he looked at a landscape, he would find hidden walls he couldn't avoid.

"I was in an emotional rut and began painting execution walls. From there suddenly one day, I woke up and thought about the Kotel, the wall around the temple in Jerusalem. So I started painting that and then painting the temple inside."

This piece is transitional and one of the earliest canvases of Fred's that still exists. It holds a landscape of the future and the execution walls of Fred's past.

Part 2

To live through it was luck.
To live with it was the skill.
It still is.

My experience is what happened to me. It's there.
I can't make it go away. I just have to live with it.
The camps are a bass playing inside of me. It is
always there. I've learned to play the fiddle over it,
not because that drowns it out but because it creates
some harmony in my life. Art is one of my fiddles.

— Fred Terna

Introduction

Fred has told and retold his experiences during the war so often that they are at his fingertips when we talk. Even the parts he doesn't usually tell are available at the front of his memory. When we start talking about the time after liberation, it does not come as easily. Imagine if I asked you where you went grocery shopping 10 years ago, what you might have made for dinner, the flavor of your child's birthday cake. The memories just aren't there. There are days that stand out in Fred's memory that we talk about in great detail and entire decades that run together through time and space.

I considered trying to retrace Fred's path from Prague to France to Canada, and eventually to the United States. It would allow me to add a little detail to what Fred might have seen, heard, tasted, but what would it teach me? And what would that tell you? I decided instead to focus on what Fred does remember and what we can learn from that; I

supplemented that with research about what was happening in each of the places he lived at the time he was there.

Within what Fred remembers, there are days that are clear for him, many unique to him and to the way Stella dealt (or didn't) with her painful memories. Some of them are the same days that are clear in my own memory, too, like the day he and Rebecca decide to buy a home, much as my husband Brian and I had; or days that I hope to reach, like the conversation that allowed his son Daniel to enter their lives. The theme is that life went on. He found ways to be happy, to build relationships, to tell his story, and to trust.

It's not an uncommon sentiment for Holocaust survivors to believe their own survival was luck. Having heard his story in such depth, I agree that his physical survival is almost entirely coincidental, though arguably his certainty that he could survive, and insistence on continued learning to plan for the future, provided necessary mental and emotional fortitude.

The memories of the war and the trauma he experienced never go away, despite his belief in the hospital bed following liberation that he would eventually be able to move on. The vestiges are still there more than seven decades later: Fred keeps extra pairs of shoes in case emergency strikes. He freezes up in front of police officers, momentarily finding himself someplace where the appearance of a guard might mean torture or death. He somehow allows those moments to pass, pulling himself back into the present. He never learns to forget trauma, he learns to live with it, and even to create beauty out of it through his artwork.

This left me with important questions that would not allow the book to end here despite how much less vivid Fred's memories are after

liberation: If "living with" is what takes skill, what are those skills? How does one develop their own internal fiddle to play over the ugly tune of traumatic memories that can never be escaped? The remainder of the book is about telling Fred's story, but it is also about attempting to answer these questions and sharing the lessons that come through both in his story and in his art. These themes are what I explore in the coming pages; I hope they allow all of us to live a little bit more fully despite the challenges we face or the chaos of our past. I don't embellish what Fred has told me, so if the story seems less complete, it is because he doesn't have the same urgent need to share what comes next. The story is less practiced, and, on several occasions, he asked if he was boring me. To me, the fact that after what he has gone through, he can live to one day have a "boring" life is perhaps the most remarkable statement of all.

Chapter 12

The First One Back (Summer 1945)

"Y ou're the first one back," the building caretaker told him. She didn't know yet that he would be the only one back but after all he had seen, he suspected that no one else was coming home. She had aged since he last saw her, her back bent more than it used to, but she remained a sweet old woman. "A lot has changed since you've been away. I'll take you up to your family's apartment but I should warn you, someone has been living there during the war. I don't think he'll take kindly to this." It was the summer of 1945 in Prague. Fred was 21 years old. The #16 trolley had taken him home.

The elevator was in the center of the round staircase in the historical building. The caretaker pulled open the chain link door and he stepped with her into the elevator. The ride seemed to take forever, his legs weak from standing; since getting off the train, he had waited for the trolley,

taken the steps up, stood for the trolley ride, and then stood on the first floor and now in the elevator. He knocked on the door to his own home and waited until someone answered.

"What do you want?" the gruff voice asked.

"I'm...my family lived here. Before. I'm coming back from a concentration camp. This is my home."

"It was your home. It isn't anymore. I've been living here for a year," his voice rose as he spoke, "do you know my position in the government? Do you know how important I am? And you come here like this? Well, I must tell you, I've heard what they did in those camps. You must have been quite a scoundrel to survive!"

When Fred opened his mouth to protest, the man shouted, "If you keep this up, I'll make sure you're jailed for bothering me this way!"

As the door closed in his face, Fred realized it was not just the apartment that was rightfully his, all the furniture in the entryway had once belonged to his family as well.

The super hadn't expected it to take long. She was waiting for him in the elevator. He walked back toward her slowly. She was small and Czech. Not Jewish. Older than his father by quite a few years. They had assumed she would live, would still be here when the war ended and the family had agreed that when it was over, if they had been separated, they would meet back here and she would be the keeper of where they were so they would be able to find each other. Already Fred was starting to suspect that there would be no family to find but he remained hopeful.

"There was a girl," she told him as she brought him back down. "She stopped in a little while ago. She lives a few blocks away. I have the address. Asked me to let you know she had been here if anyone from the family came by."

Stella. In Terezin, he had been so certain of everyone's survival, including his own, that he had told her when they separated that their super was the family's keeper of information. Of course, she knew where his apartment was, and that way they would be able to find each other after they were liberated. He took the address.

He walked the few blocks to her home, thankful that it was so close by. He was too weak to walk much farther. The streets, the building, the stairs were all familiar, and yet he could not really feel anything towards them. It seemed as if the city had aged a century while he was away. Indeed the worst of the war for Prague had happened in the weeks between Fred's liberation and his arrival home; he never cites it directly to me, but historical sources suggest he would have found a city largely destroyed and with many of its cultural artifacts irreparably damaged. In the weeks Fred spent recuperating in May 1945, complete pandemonium reigned in Prague as an uprising to liberate the city began. With the help of allied forces, the remaining Czech underground fighters had taken to the streets, where they turned on the German SS and began rounding up and imprisoning or randomly killing anyone associated with Germany — whether SS or Czech-born. Czech citizens had gone as far as to forcibly remove Germans from homes commandeered from those the SS had rounded up and sent to their deaths and claimed those apartments as their own instead of the bombed out buildings they were currently living in. Like Fred's own apartment, those who moved in were not inclined to turn these homes back over to returning Jewish owners.

They had lost their homes and felt they had suffered too.

Everything was numb as he arrived at Stella's apartment, walked up
the stairs, and knocked on the door. His 5'10" frame was just over 100
pounds. He heard footsteps inside, the knob turning. She opened the
door.

They last saw each other less than a year ago when Fred was shipped out
of Terezin with only a few hours' notice.

"Yes?" Stella said, "What can I do for you, sir?"

For a moment, he was dumbstruck. That she wouldn't recognize him,
that he was able to see her again, that they were both here, now, after all
of this. That they had both lived, made it to Prague, found his super, and
found each other again.

"Stella. It's me."

She had known somehow that he was in Kaufering last, and she had
heard from somewhere (Fred doesn't know how) that there were no
survivors from his transport. She had likely already written off the
possibility of Fred's survival. Of the approximately 92,000 Jews in
Czechoslovakia before the war, not even 14,000 had survived.[22] Like
so many others she had known before the war, he must certainly
be dead. To Stella, it must have been as if a ghost appeared on her
doorstep; even if he did look familiar, perhaps it was a form of mental
protection to refuse to believe it was the boy she'd been in love with as a
teenager. When the recognition came, they were in each other's arms.
Rediscovering what it meant to have each other.

There is no one left to ask, but I wonder whether his appearance rekindled hope in Stella and her sister Eva that others they believed were dead might be coming back. How long did they wait before they gave up? Fred tells me it was a few months, but for Stella, for whom a teenage love had just come back from the dead, I can imagine passing someone on the street who looked familiar and feeling her heart skip a beat each time for the rest of her life. How many times did they mourn those losses?

Fred struggles with the emotions this story brings up in a way that happens extremely rarely when we talk. In his studio with me, he tries to mask how upset he is by suggesting it's time to take a break and eat lunch. It isn't his emotions that are a problem, it's time. I tell him it's only 10:30 and he admits for one of the only times that he just needs a break before he can go on, so we sit quietly together for a few minutes.

Stella and Eva survived Terezin, Auschwitz, and Flossenburg, a concentration camp in Bavaria. In our conversations, Fred attributed their survival to the sheer force of Eva's will. Like Jan, Eva had decided early on that she and Stella would do the work they were given, eat what they were given, and survive this. That they would not be separated. That they were going home. It worked better for some than others.

Fred moved in with them. Stella and Eva were the only two in their family to survive and their super had told them while he couldn't let them back into their old apartment which was large enough for a family, he had a smaller option. They could move there. And so, the three of them lived there together, reacquainting themselves with the world. If they paid rent, Fred doesn't remember it. Stella and Eva, the Horner sisters, became his family.

They worked. Or tried to. But often they got the same response Fred had gotten at his own apartment door. The people they had known before hid from them. Afraid to make eye contact.

As the end of the war had neared, the Nazi regime was in desperate need of labor. Throughout Prague, they closed factories that supported the textile and leather industries and reopened them to work in metals and chemicals. Propaganda intimated that Czech people should expect to live under German or Russian rule forever and suggested that Germans could appreciate Czech culture while Russians never would. The Czech resistance had been almost entirely squashed before the uprisings in 1945. What few acts of resistance were undertaken were caught and perpetrators were publicly arrested, tortured, and executed to scare off followers. Czechs became more apt to accept reassignment to wartime activities. By 1944, Czechs were doing little to sabotage German war efforts despite pleas from Allied forces.[23] Still, Germans continued to punish Czechs for their difference: at the end of the war, more than half of Czechs were malnourished and going hungry. Clothing and shoes had become scarce. Those Fred and Stella met in Prague would have felt both guilt for not resisting more and anger that their suffering had also been so extreme.

Even as the war wound down, Nazi sympathizers used their influence in the newspapers and media to proliferate anti-Semitic rhetoric by accusing Jews of being too rich, successful, or at the very end, too "German," turning the blame for their deportations and deaths back on Jews themselves. Czech citizens, guilty and looking for someone to blame, pointed out that some Jews embraced German language before the war, proving that Czech Jews were not truly Czech. Fred may not have had Jewish friends in school before the war, but he was not the only

child to have been educated in a dual-language German school. In the name of national unity, in some areas, Czechs continued to lump Jews returning from concentration camps in with Germans and subjected them to continued persecution. Hating German people and all things German was a single unifying ideal on which all could agree in the aftermath of the war, even if that hatred or mistrust was taken out on returning Jews.

A few people did find Fred. Between being in hiding and shipping out to Lípa, Jews had not been allowed to own bicycles. Fred had given his to a non-Jewish friend and shortly after he found his way back to Prague, the friend appeared at their door with the bicycle, battered and without tires, but still functioning. They never spoke again, but a lifetime later and an ocean away, Fred still recalls the kindness of the gesture.

Eva reconnected with a boyfriend, Paul. They got married at City Hall. To Fred, it was a foregone conclusion that he and Stella would marry as well. He never proposed exactly and certainly there was no engagement ring. One of the biggest challenges was that he had no literal proof of his existence. He was doing his best to find papers his father had left hidden with various business associates, but it was a slow process. In the meantime, he went to the police station to try to get documents that would at least allow him a marriage certificate. It was a matter of the right officer being in the station at the right time. He tells me that he needed to find someone with compassion, instead of someone who thought "another dirty Jew." The officials he spoke to were as confused as he was about what to do, so when he found a businessman who knew his father, he brought the man as a form of ID to confirm to the officials that he was who he said he was. Through a combination of luck, his father's friend's willingness to vouch for him, and a sympathetic official,

Fred managed to procure a marriage license.

With Eva, Paul, and two surviving friends as the four required witnesses, Stella wore her best — her only — hat. Fred wore his best pants. There was a picture of the wedding at some point; Fred says they looked like six criminals standing in a line.

Sitting in his kitchen after the tour of his studio when this project started, I asked Fred how he met his first wife, Stella. The answer was short: "After the war I moved back to Prague. There were six Jews there, three men and three women. So, we all got married." With so little family left to find, together, they began building their own.

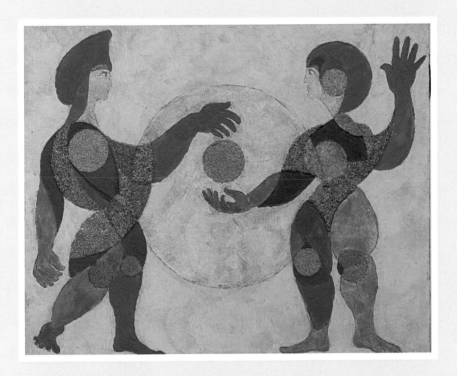

CONTINUED EXCHANGE, 1971
Acrylic and aggregates on canvas, 40 x 48 inches

Built almost entirely of differently textured circles and seeds, this piece shows two people on the edges of one circle together exchanging the safety and danger of another darker circle as a pair. It's rare that Fred directly depicts people, but they do weave in and out of his work, often in pairs dancing or interacting in some other way with one another, as they do here.

Chapter 13

Unable to Make a Life in Prague (1946)

Throughout Europe, those who had been recently liberated were struggling to figure out what to do. Many were too frightened that the anti-Semitism they had experienced before the war had not been eradicated with the defeat of the Nazis and might resurface in the countries they had lived in before the war. Historical estimates say that a quarter million people were housed in displaced persons (DP) camps throughout Europe in the years that followed the war. These DP camps were often created out of former concentration camps, and at times people were placed in them by nationality. This meant that in some locations, recently liberated Jews lived alongside those who had imprisoned and tortured them and killed their friends and relatives. Thousands of people died due to the conditions of the DP camps.

In June of 1945, the American delegate to the Intergovernmental

Committee on Refugees visited these DP camps, and reported back to President Truman that, "As matters now stand, we appear to be treating the Jews as the Nazis treated them except that we do not exterminate them. They are in concentration camps in large numbers under our military guard instead of S.S. troops."[24]

What little attention was being paid to Jews in the aftermath of the war was on these DP camps, with Jewish relief organizations largely leaving the care of returning Jewish citizens to local governments that were otherwise occupied.[25] There was little in the way of assistance for Fred and Stella in Prague, and they had to figure out how to rebuild their lives largely on their own. Fred was still quite ill. He moved into a hospital in Prague. If he was asked to pay for it, he doesn't remember. Fred had no way to find out about any organizations that were offering assistance to survivors outside of DP camps.

Once back out of the hospital, there was no time to dwell on his experiences; there were too many practicalities that required attention. Fred, Stella, and Eva continued trying to find the formal records of their lives: birth certificates, passports, all of these missing papers that had made it difficult for Fred to get a marriage license were now making it impossible to find work. As mentioned earlier, Fred's father had had the foresight to store papers with a variety of friends, neighbors, and business associates. There were still two sets (Taussig and Terna) that could be recovered, and that duplication increased the odds that at least some of the paperwork had survived. Fred made his way slowly around the city; knocks on doors often went unanswered as people tried to hide from him. When doors did open, he caught glimpses of things he recognized. Next door to his father's apartment was a police officer who claimed all of the rugs and other items in his apartment from Fred's home had been

sold to him before the family was shipped off. Fred had no right to them anymore; the officer claimed to have paid good money for everything. Fred found his father's collection of books about Abraham Lincoln there. The books were in English, which the neighbor could not read, so they were of no formal use to the officer — perhaps just part of the collection of things they had helped themselves to in the apartment. Fred did not dare to ask for them back after the icy reception he'd had in his own apartment.

Having lived through what he was coming home from, he knew there was little significance to physical things. They were no guarantee of anything, and he had lost things of much higher value than rugs and books over the last few years. In his writings, Fred described his home before the war saying, "There were heavy curtains and drapes, Persian carpets on intricately patterned floorboards. All this was somewhat intimidating for youngsters of our age and did not lend itself easily to romping and raucous play. It did however radiate an aura of security, of solid values."[26] He knew by then that security had been an illusion, that his home with its heavy furniture could not really protect him. Still, he says to me in an early interview that he wishes he could have had something from his father or brother, just to hold and think of them with.

Someone did return a few pieces of jewelry to Stella and Eva that had belonged to their family. The gold was valuable, and the sisters divided it between them and sold it on the black market, needing money far more than fine jewelry.

Fred, Stella, Eva, and Paul lived together in the apartment the Horner family's super had allotted them when they arrived home. Fred found it unpleasant, largely because the better he got to know Paul, the more

he hated the man. Fred still describes Paul as a scoundrel and remains visibly angry with him. He began an affair with another survivor almost immediately after marrying Eva, which Eva tolerated. Fred keeps track of people over time: he tells me the woman Paul had an affair with is alive and lives in Queens. During the war Paul had contracted syphilis, which was never properly cured and so he infected Eva, still weak as she was from her own time in the camps.

Fred did his best to share news where he had it. The few who had survived were all hoping against hope that their loved ones might return. If Fred knew of someone who died in the camps, he felt it his responsibility to let the family member know where and when it had happened so that they weren't left wondering. Fred knew about people with whom he was in Kaufering, his final concentration camp. They had shared stories about their homes to keep themselves warm and sane. The men he had heard the stories from were all dead, but he knew where they had lived, and he went to see if anyone who knew them was still there. He had worked alongside a man in Kaufering who had a daughter Fred went to find. The man's wife was not Jewish, and he divorced her before the war in an attempt to save her. It worked; Fred found the daughter and gave her the news that her father had died.

Throughout the city, he knocked on doors, and if they were answered, said, "I was in Kaufering with so-and-so. Is anyone looking for him?" trying to be very careful and not say how people died; it was too gruesome to imagine sharing with a loved one that someone froze to death, was bludgeoned, or shot point blank for being the 10th person in line. Better to just say they had passed, and when.

When Fred told me about this, I had trouble imagining putting yourself

through the pain of telling people you didn't know over and over that their loved ones were dead. Why did he bother when they would have figured it out eventually? I might still not understand if someone hadn't done the same thing for my own family. In my great uncle's memoir, he said, "In March 1945 we received a letter from England. A young woman who knew my wife had spent her last weeks with my wife's parents in Auschwitz and she gave us a detailed report which stated that my parents-in-law had died in 1944." Though not the news they wanted, the fact of someone confirming the fate of their family members acted as a release — they no longer needed to wonder or search. Instead they could mourn and try to heal. Fred's trips through Prague and surrounding areas must have done the same thing for those he spoke to, creating space for healing. Eventually, these conversations took up less time, and Fred could stop focusing so much on the past and begin focusing on building a new life.

He finally managed to pull together his original birth certificate and what few other papers still existed from the various people his father had entrusted these documents to. The paperwork proved that he was who he said he was, and put the formalities in place for him to obtain work, granting more flexibility than they would have had otherwise. Unfortunately, either all of the visits around town to secure papers or his marriage to Stella had brought him to the Czech government's attention. He received a letter reminding him that he had shirked his army duties at age 18, when he was in a concentration camp, and that he would have to serve now at 22 or face prison. He had never felt welcome in his return to Prague, but of all the injustices he encountered, that one in particular galled him. He went to the army's offices at the appointed day and time and was issued a rifle, which he promptly threw out the window. He was court-martialed, but somehow (despite many questions about it, Fred

was not able to tell me exactly how), he eventually managed to get out of the service. It was the process of fighting his draft ticket that made him realize he would not be able to make a life in Prague. Stella was simultaneously finding herself out of place; she still felt Viennese, and the return to Prague was ill-suited for her. It had never been home and was even less so now when there was no one to welcome her back. They had waited long enough to be certain they were their only surviving family. It was time to move on.

Fred was also terrified of what would happen to them under the quickly rising Communist government, which seemed to embrace many of the same tactics that had been utilized under German rule. Throughout the war, Nazi officials from the Race and Settlement Office x-rayed Czechs to look for signs of Aryan ancestry under cover of checking citizens for tuberculosis. The German government engaged in continual back and forth over whether Czech citizens could become German or not. After the war, "the state-run process of identifying, segregating, and then expelling individuals continued with strikingly similar methods... when the Czechoslovak state embarked upon the 'organized transfer' of Germans."[27] In late 1943, members of the Czech government who had been exiled to London had signed a treaty with the Soviet Union, and announced an intention for a Czechoslovak nation that was nationally homogenous. Between the time when Fred arrived home and 1948, more than three million Germans were expelled from the country.[28] Hating Germans had become an easy way to prove one's national pride, and the government granted amnesty to Czechs who had robbed, beaten, or murdered Germans at the end of the war and in the months following. Czechs were angered that the American and British governments gave only tepid support to their plans to relocate millions of Germans out of Czechoslovakia; the Soviet Union and local Communist parties were

ardent supporters, and Communist representation in government grew quickly.

Fred found this growing nationalist pride around them disconcerting — he was all too aware of how quickly it could turn on him. He wanted to move to another country, where he hoped to feel safer. He and Stella began planning an escape. Stella had uncles in America and they desperately wanted to follow them. They explored moving to the United States. President Truman had passed the Truman Directive in 1945, requiring that the existing immigration quotas include space for displaced persons. It would not be until 1948 that Congress passed legislation to admit 400,000 displaced persons to the US, but only about 20% of these would be Jewish. The limits were significant. There were millions of refugees throughout Europe; the best Fred and Stella could hope for was to be on a waitlist. They applied anyway.

In the meantime, he would only consider options for locations where they could easily get to what had been an allied country in case things got out of hand. They settled on France. From France, they could quickly get to England if another war broke out or they found themselves unwelcome in France or wherever they made their home. Through a friend in Prague, they were introduced via post to a survivor who had known Fred's father and was making a living as a journalist in Paris. Fred and Stella resolved to go to Paris and join him.

Unfortunately France was also overwhelmed with its own returning citizenry and refugee crisis and was avoiding accepting Jews from other Eastern European countries who might strain already limited resources.[29] Together, he and Stella came up with a story for the trip: Fred needed to go to France to meet with clothing manufacturers that

in pre-war days used custom cheap jewelry made in Bohemia; there was a large French market for it again after the war. They wrote fake letters back and forth about the industry with their journalist pen pal. Fred made sample cards and collected costume jewelry from people around him so that he would have a collection to present the border crossing guards.

With all that fakery, he still needed exit visas from Prague. He needed signed permissions from a number of agencies: from the military that he was not needed for army service, from the police that he had a clean criminal record. Then a transit visa into the American zone and out of the American zone. Then from the American zone an entry visa into the French zone and an exit visa, and a business entry visa into France. It took time, but he secured the necessary papers using the false letters as proof.

At the time, a wife could travel on her husband's passport so they did not need papers for Stella, but they needed a reason that she would be on a business trip with him. They lied and said that Fred didn't speak French but Stella did. Through a stroke of luck, when they met the border crossing agents, nobody tested Stella's French (which was non-existent, though Fred's was quite strong).

As early as that train ride, Fred hoped that they would eventually get to New York. He resolved that they needed to start preparing right away, and he and Stella agreed to speak only English to each other in order to be ready when their opportunity came.

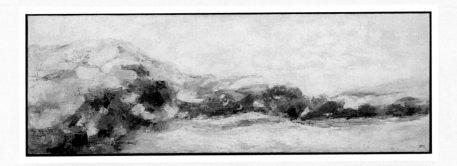

THICKETS ALONG BROOK BELOW ROLLING HILLS, 1971
Acrylic and aggregate on canvas, 20 x 60 inches

"There are certain intangibles between husband and wife that get communicated without being clearly spelled out or being fully aware. It's a kind of osmosis of ideas. When I painted a sweet landscape, Stella would comment: What is bothering you? Knowing...being aware of my escaping into a never never land."[30] After what they had lived through, nowhere would ever feel entirely safe. When Fred tried to paint safe space, Stella knew things were particularly dark for him.

Chapter 14

Gaining Strength
(1947)

I n France, everyone they met claimed to have been part of the
resistance during the war. Fred was certain that most of them had
been passive at the time and were now grappling with guilt over
that. Perhaps they had not hated Jews, had not wished this on
them, but they had not stood up against it either. The French at this time
"viewed the history of their nation during the Second World War as an
aberration, which was to be either forgotten or obfuscated through the
creation of reassuring narratives of collective resistance and suffering."[31]
In French guilt, refugees found a grudging willingness to accept their
presence in Paris.

Fred's father's friend in Paris, with whom he and Stella had written
back and forth, found a hotel for them before they arrived and sent the
address in advance of their trip. The room held was too large and too
expensive, so they rented instead a single room on the top floor with a

bathroom down the hall. It was a bitterly cold winter; food was rationed and both Fred and Stella had little weight to lose. In the refugee areas, Fred would listen for languages he understood and find others to speak with, ask questions of, and learn from. The refugees all shared news of what limited help was afforded to them: there was a soup kitchen nearby, and a little bit of aid in obtaining new clothing. They should feel lucky to live in crowded apartments on top of each other; those in less fortunate circumstances were living on the streets. With quarters so tight, tuberculosis tore through the refugee community in Paris;[32] Stella was among the many who contracted the disease that winter.

Though it was possible to do so, few of the French were surviving on rations alone; most had a connection in the countryside who would get them a little extra. France had plenty of food, just no easy way to transport it between the countryside and the city. Fred and Stella wrote to her relatives in the US and asked for help, anything they could send. Every few months, someone would respond with a care package, usually of cigarettes, that could be traded for food. This was common: my family in New York did the same for relatives in France and distant German cousins who had married non-Jews generations before. They survived that time as a result of packages from my grandparents.

For Fred and Stella, even with that little bit extra, Paris in 1946 did not agree with Stella. She was sick. And she didn't like being in another city, surrounded by walls as they had been for so many years.

Fred found a doctor with no connections outside the country, aware that if they ever wanted to immigrate to the United States, they would have to hide her tuberculosis. He could not risk being turned away because a doctor shared information on their health with the American embassy.

The doctor Fred found suggested rest, exercise, fresh air, and sunshine, none of which they could easily find in Paris.

The journalist they corresponded with from Prague had since moved to the French Riviera and they decided to follow. They boarded a train and arrived in Beaulieu-sur-Mer, a small town in the south of France between Nice and Monte Carlo. For a night, they stayed with the man who had previously been only a pen pal. The next morning, he took them to the mayor, who was responsible for handing out food ration tickets. Immigration in the immediate aftermath of WWII was approximately half that of immigration between the World Wars, so immigrants would have been few and far between in such a small town.[33] Fred dressed in a suit he had bought after the war and their friend introduced them to the mayor as "newcomers" avoiding using the word refugee. The mayor mistook Fred and Stella for tourists and was overjoyed that tourism was starting again. None of them corrected him, and eager that they should go home and tell their friends to visit, the mayor gave them extra ration tickets; a little bit of extra food and coffee, but mainly, extra tickets for wine. They were to receive half a liter of wine a day, compared to the average Franc who was receiving a liter a month. With little use for wine, Fred and Stella traded these extra tickets for additional food tickets from locals. They went to farmers for milk, butter, and eggs, foods Fred had hardly dared dream of during the war, when all he wished for was to eat something hot. The food was important for both of them, but particularly for Stella who continued to struggle with tuberculosis and with after-effects of whatever had happened to her in the camps.

With access to enough food secured, their next task was to find a place to live. Fred describes his French at the time as "passable" though he seems

to have been almost fluent. They found a real estate office and told the man they met the truth: they had no money, and only a little bit extra in food rations. They weren't planning to stay for long and had no way really of supporting themselves. Miraculously, he had just the thing.

The man brought them to a beautiful villa, which was fenced in at the center of a park. It had a four-car garage and overlooked the Ville Franche bay. They looked out onto the entire Mediterranean.

"You can have this Villa while you're here," he said.

"What?" Fred assumed he had misheard as he stared up at the castle in front of him.

"It's yours to live in. The villagers have been looting. Things are going missing. Silver, chandeliers, chairs. Slowly, but more and more. You are responsible for ensuring nothing else goes missing this way. You must have laundry outside at all times. But change it every day. Play the radio, loudly, at all times of night and day. Put large amounts of trash in the bins. Make it look like many people are living here, not just the two of you. And care for the house." Hardly believing their good luck, they moved into the castle. Their particularly impressive accommodations reinforced the mayor's notion that they were high-class tourists, and they continued to receive extra ration tickets.

They spent their days enjoying the warm weather, gaining strength, drinking fresh milk, and taking long walks along the peninsula, Cap Ferrat. On these walks, Fred noticed that Stella could no longer jump. She had always been clumsy, but for a reason he never understood, after the war she could not even easily step off of a curb and into the street;

the distance from the step to the ground was too far. He never asked her what they did to her to cause that fear. In fact, they avoided talking about the war altogether; there was no reason to. They both knew the horrors they had experienced; both had their own memories to relive in nightmares; what good would it do to re-live during the daytime too?

Psychologist and survivor Victor Frankl noted of himself and his patients who had survived the Holocaust that they often said, "We dislike talking about our experiences. No explanations are needed for those who have been inside, and the others will understand neither how we felt then nor how we feel now."[34] To Fred, it was one of the benefits of being with someone who had been through what he had; they weren't pretending it hadn't happened, there was just a silent agreement between them that it didn't need further exploration.

They created a routine and learned to tamp down their terror. They reminded each other that they were free, that the camps were closed. They eased back into day-to-day life, forced to do so by the need for food and clothing and a mandate to maintain the castle they had lucked into.

Over the six months they were there, Stella's physical health improved. Fred sketched or painted a little bit (the most challenging part then was finding materials in their small town) and looked for work. They foraged for wood to light fires to stay warm at night. They began discussing going to New York. There wasn't much to do here, though most of their needs were taken care of.

Despite being exceptionally bright and speaking half a dozen languages between them, neither Fred nor Stella had any real marketable skills, nor were there many places to work in this small village. Eventually

Fred found a company that designed fliers for local restaurants that were given out by ushers at movie theaters. Fred created the layout of these handouts. It wasn't a lot of money, but it was something. Their rent was nearly nothing and even after their tourist rations ended, they continued to receive extra rations of milk to help Stella's tuberculosis.

One day walking along the peninsula together, they made a left instead of a right and crossed into an area they hadn't visited and were quickly accosted by a man yelling at them in English. They had crossed onto his property and he seemed incredibly unhappy about it. Fred's arm around Stella, they turned quickly to walk back. Fred's English might have been good enough to decipher why he was being yelled at, but the man was speaking too fast and they saw no reason to engage him. On their way back into town, they ran into an acquaintance who, taking in their still shaken expressions, asked where they were coming from. When they described where they had been, the man shook his head.

"Of course he was yelling at you — that's a minefield! They're still active there!"

The war zone was not merely a mental construct.

Fred and Stella found themselves growing lonely. They had never planned to spend long in Beaulieu-sur-Mer. Eva was still back in Prague, and they had not made many other friends; the area was not hosting many other refugees. Eventually, with the weather turning and the chance for walking along the sea each day starting to slip away, they decided to return to Paris, continuing to cling to the idea that one day soon, they would leave Europe behind for New York.

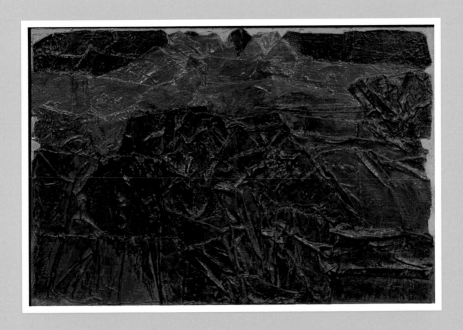

CRAGGY CLIFF, 1966

Canvas construction and acrylic on masonite,
24 x 36 inches

This craggy cliff is painted over folded and pressed pieces of canvas, creating texture in an otherwise consistently dark piece.

Chapter 15

The Mechanics (1947-1951)

Ⅰn the winter of 1947, Stella and Fred returned to Paris and rented a small furnished room to be closer to community and find work, which was more readily available in the city than the countryside. Unlike Prague, which had been largely destroyed in its quest to drive out the Nazi regime, the iconic buildings of Paris were left largely untouched.[35] Survivors in Paris were clustered in a few areas where they could easily access what aid was available to them. Fred and Stella returned to the same area they had lived in briefly before, renting a small furnished room in an area with a large refugee community.

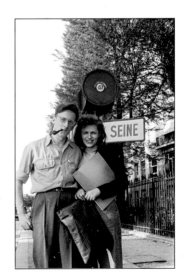

On an evening walk around the city, Stella and Fred ran into another Terezin survivor, Ruth Baeck. They stopped to chat, catching up about their lives since the war, how they had each made it to France. The unspoken dead hung over the conversation — they did not ask one another who they had lost; the list of who survived would have been shorter. When Fred mentioned that he had not been able to find work, Ruth told him that the American Jewish Joint Distribution Committee (JDC) was looking for bookkeepers.

Initially funded by Jewish philanthropists in New York, the JDC was founded during WWI and, by its own description, "was the first Jewish organization in the United States to dispense large-scale funding for international relief. World War I left in its wake the seeds of many additional catastrophes — pogroms, epidemics, famine, revolution, and economic ruin — and JDC played a major role in sustaining Jews in Palestine and rebuilding the devastated communities of Eastern Europe."[36]

When the United States entered WWII, the JDC formally had to close any offices in enemy countries; they had ostensibly closed their European offices though they continued to provide some aid through back channels and local organizations. Their office in Paris reopened in 1944. From 1929-1939, the JDC "raised and spent almost $25 million on relief, between 1939 and 1945, it raised more than $70 million, and between 1945 and 1950, it raised approximately $300 million."[37] There was tremendous demand from survivors and aid was pouring in; they were struggling to keep up with matching donations to requests. In 1947, when Fred met Ruth in Paris, the JDC was in the middle of this growth spurt and in desperate need of additional staff. Ruth gave him the address.

The next day, Fred went to the Parisian office and told them he was looking for a job. Did they need any help?

"What kind of job? What skills do you have?"

"I am a bookkeeper."

"A bookkeeper! We have needed one! Let me bring you in to meet with the head of bookkeeping right away!"

It was of course, not strictly true. Fred's father had taught him some of the very basic fundamentals about bookkeeping as part of their lessons after Fred was kicked out of high school and he managed to hold his own when asked about credits and debits and how to create the accounts. When his future boss asked him how to account for a particular example, though, he gave an answer that made some basic sense to him but to his American interviewer, it sounded like gibberish. Fred watched the interviewer's face fall and was afraid his bookkeeping career — his shot at supporting himself and Stella — was over already.

Sam Haber, who had joined the JDC in March of that year as director for the American Occupation Zone of Germany,[38] was in Paris visiting, and without Fred saying anything, Sam recognized a survivor standing in front of him. Over the course of his life, Sam would be credited with saving or assisting nearly half a million Jews.[39] Sam stepped in.

"You know, I think he's right."

"What?"

"Well, if you were keeping accounts the European way," he drew out a

sketch on paper, "certainly this could be a correct answer."

Fred was hired but was never asked to manage financial documents for the organization.

Instead, Fred was put in charge of managing lists of immigrants as they were processed through the JDC, tracking refugees who passed through Paris as they were processed towards their final destinations. Another department was helping oversee refugees immigrating to what would become the state of Israel six months later, and Fred was transferred to that unit shortly after starting the job.

Stella was still recovering from tuberculosis and could not work steadily. The medicinal cures for tuberculosis were a few years away. Instead she managed the cooking and cleaning for the two of them. News came that Eva and Paul had their marriage annulled and Stella asked Fred to help get Eva to Paris. In Dr. Edith Eva Eger's memoir about how she and her sister survived the Holocaust, it's clear that Edith and her sister were able to live because they had each other to live for. If one of them had died, the other could have felt the freedom to follow, but for as long as the other survived, they were each motivated to stay alive. I wonder if Stella and Eva had gone through a similar period together. It is easy to imagine how painful it must have been for Stella to be so far from her sister for the first time since that experience. Fred's memory of how he did it is lost, though he recalls that the move took considerable ingenuity. Eva soon joined them in Paris.

Eva remained strong-willed with an entrepreneurial spirit, which infected Stella as well. Eva was living in a small flat very close to Fred and Stella's. Through a friend, Fred managed to get Eva a job painting

textiles, for which she turned out to have some talent. The fashion at the time was skirts with big colorful flowers painted on them. They had to be bright, simple, and cheap. Still in charge of both of them in some ways, Eva had Stella join her and the sisters began churning out skirts; the pay was low, but Eva managed to cover her own rent and food, which was enough.

Eva began dating an American in Paris on the GI Bill. Though his relationship with Eva didn't last long, Lou and Fred hit it off, and Lou began introducing Fred to other Americans. Lou was there studying art and took Fred along for classes in painting. Informally, he joined Lou when he could at Academie de la Grande Chaumiere and the Academie Julien, where he learned more about the mechanics of painting and was inspired by the work of the Cubists and post-Impressionists. If one had to categorize his work, it would still fit that description. Though his coloring and subjects have evolved, he hasn't undertaken major changes to his artistic style over the course of his career, not particularly bending to modern or postmodern influences. Much of that can be traced back to these early days of study in Paris.

Through this friendship, Fred built a community of American artists. Of the 8-10 artists in the circle of friends, only two were Jewish, and none were painting on Jewish subjects. Fred became acquainted with John Taylor and his wife Andrea Ruellan, who lived in Woodstock, NY, and were in Paris, perhaps visiting Andrea's family. He learned about oil paints from watching and listening to John and started painting small canvases himself. Oil paints were particularly convenient for their small apartment because they did not take up a lot of space — they came in small tubes. Eventually he bought a traveling easel. Fred says the work he made during that time was neither artistically nor emotionally

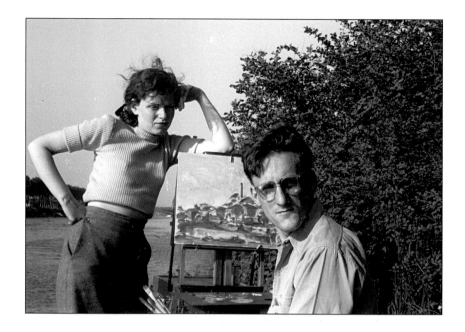

impressive — he was practicing putting paint on canvas and improving his technical skills. That was what he needed then.

He sketched and painted the streets of Paris or views of Prague from memory. He and Stella would travel to Versailles or Notre Dame; she would walk in the sun (the only known way to improve tuberculosis) and he would sketch or bring the folding easel and tubes of oil paint. During his lunch breaks at the JDC, he sketched in the gardens he sat in to eat.

At the JDC, Fred worked with Lucy, a South African woman in the accounting department, who was writing what he quickly figured out were false reports about where ships carrying immigrants to Palestine were going and what they were carrying. Though she tried to hide it from him, Fred figured out what was going on quickly, and the two of them agreed to start sharing information and working together.

A boat might go to four or five ports before landing in the Middle East somewhere that an Israeli was waiting to sneak the refugees off the boat and (illegally) into Israel. Occasionally, a boat would be caught by the British, but most were successful. Fred's job was collecting numbers: how much did it cost per person per leg of the journey. How much of that money was legal and how much had to be recorded in some other way. Once he had it in ledgers, four auditors would review the information before making decisions about how many people to send, and how to allocate the funds to do it.

Together, Fred and Lucy falsified records regarding spending to cover for ships of people immigrating to Israel. Eventually, Lucy returned to South Africa and Fred took over the department completely. He calls this his "heroic time... the time I was part of history."

Certain details remain crystal clear in Fred's mind. When he first told me about Lucy Hoddes, he was able to spell her last name, though he commented he had not spoken about her in some years and that she was not an especially significant person to his story. Hours of searching through the JDC's online archives turned up two documents referencing her: one an internal memo in which she requested a corrected receipt, the other a note from someone in the Parisian Accounting Department to the New York Accounting Department commenting that Lucy would be moving to South Africa in early 1951. Though his memory for people is vivid, his memory for dates after the war is cloudy — it is by finding Lucy in the JDC records that I rebuilt the timeline of Fred and Stella's second stay in Paris.[40]

Tangentially, this work put Fred in the middle of a raging political debate between leaders in the Jewish community about whether there was still

any place for Jews in Europe after the atrocities that had just occurred. On one side, staunch Zionists argued that after what had happened, Jews could never feel safe in European countries; the most they could hope for was to live in the shadows and avoid notice. On the other side were arguments that the focus should be on rebuilding the communities that had been torn apart and supporting the re-integration of Jews into local cultures; this argument staked a claim that pressuring Jews to move to Palestine was once again stripping away their autonomy.[41]

Either because of this work with Lucy or because he was curious what it was about his religion that had made the Nazis hate him so much, Fred decided to focus his efforts to improve his French by reading books about Judaism in French. Neither he nor Stella had been raised by practicing Jewish parents, so he knew little about the religion the rest of his family had been murdered for being affiliated with.

Fred's lack of connection to the Jewish community while working within it was not unusual in this sense. Of those who were rebuilding the Jewish community in France, often "it was those least committed to Judaism — those who had been able to hide out in their native countries during the war because of their close contacts with non-Jews — who had survived and were now called upon to direct communal activity."[42] Though Fred's status as a survivor from the camps may have been unusual in these offices, it was not uncommon for those leading the Jewish community to have known little about Judaism before the War. Stella was adamantly against having anything that could connect them to being Jewish in the house, afraid after what they'd just been through that they might be targeted again. She didn't speak or read French, so by keeping all his Jewish books in French, Fred was able to study without her knowing.

Even as he learned more, the idea of an all-Jewish state didn't quite sit right with Fred. Religion itself made little sense to him — it was too similar to the nationalism he had just seen with the emphasis on an "insider" group and an "other." And he could not imagine being a true believer after what he had just experienced. Over the course of his time in France, and perhaps through his work at the JDC, Fred saw a rekindling of the Jewish communities around him. American and British relief agencies had helped the number of functioning Jewish communities in France, Belgium, and the Netherlands grow from 750 to 900 over 1946-1948; between 1946-1952, the number of Jews requesting physical assistance from relief organizations went from 65,000 to under 15,000. The Jewish community in the diaspora was finding ways to cope.

Still, stories of anti-Semitic acts were not uncommon: records of Holocaust denial go back to almost immediately after the war ended; in July of 1946, 1,000 non-Jewish Poles killed over 40 of the remaining Jews in their town of Kielce after a young boy falsely accused the Jewish community of briefly kidnapping him. Of the 24,000 Jews who lived in Kielce before the War, only 200 returned; 20% of those survivors were killed in the incident, another 20% injured.[43] The average European citizen knew little of what had happened during the war, and so had little empathy for returning Jews. Anti-Semitic graffiti was common in Paris, and flyers handed out by neo-Nazis encouraged Parisians to join the "resistance effort, this time against the 'invasion' of foreign Jews and the attempts by returning Jewish deportees to regain their occupied homes and businesses"[44] as Fred had tried to do when he returned to Prague. Areas with a high concentration of Jews were prime targets for physical attacks, which were often ignored by police, or during which Jews were arrested while attempting to defend themselves.

Fred knew not everyone had the ingenuity to get out of their home country the way he had and he recognized that Paris was hardly a safe haven. Though he continued to shy away from the sense of nationalism that came with a religious state and from religion itself, intellectually, Fred understood the need for someplace safe for others in his extended community. He did his part to work towards a Jewish state where he would never want to live.

When Israel became independent, through his job at the JDC Fred was part of Operation Magic Carpet, a stealth operation that relocated 49,000 people from Yemen to Israel between 1949 and 1950. He helped keep books on the major immigrations from Northern Africa. Norway had started a program to rehabilitate Jewish child-survivors from Morocco and Tunisia in anticipation of resettling them in Israel with their families. Planes were flown to Oslo filled with children, who received medical care, and academic instruction. Hundreds of children went through the program, and Fred managed the books and the lists of children.

On November 20, 1949, two planes of children departed from Tunisia, but only one arrived in Norway. A mass search was started, and within two days, wreckage from the other plane was found, along with the sole 12-year-old survivor of the crash. Today, there is a memorial to the children at the crash site and the Norwegian government held a memorial on the 60th anniversary of the crash.[45]

The crash and the children's deaths were so upsetting, Fred could no longer do his job. He departed the JDC, distraught. It is only with six decades of distance that Fred is able to look back at the thousands of

children he brought to safety through his work and call it a time of heroism.

It was Eva who chose Canada as the family's next destination. She wanted to leave France. Fred and Stella still wanted to get to New York, but the strict quotas in place would not allow it yet. At the time, Canada was closed to immigrants except farmhands who provided cheap labor. Yet Eva found a connection there to be a nanny. She moved to Canada and settled in Toronto, promising to help bring Stella and Fred over when she could.

Still in France, Fred tried to handle his continual fear of being trapped someplace. Stella was waging her own internal battle, trying not to succumb to depression. It was in Paris that she first admitted to Fred that she was contemplating suicide. This was unfortunately common among survivors; a study done in 2005 (nearly five decades later) found that almost a quarter of survivors with mental health disturbances attempted suicide at some point.[46] Fred tried to keep them looking forward instead of backward by hanging maps of New York on the back of the door to prepare for eventually moving. He studied the roads in and out of Paris, ensuring that if something happened, he would be ready to grab Stella and go. As the Cold War started, he mapped what to do if Russia invaded Western Europe, reminding them both that it would be a short hop over to England. "I had lived through one dictatorship," he says of that time, "that was all I needed."

Fred also worried that if a war did break out, he might be drafted into the Foreign Legion. It was time for them to move on, and when Eva secured the opportunity, they joined her in Canada.

They traveled by boat to Halifax. He remembers specifically that the boat was a Greek ship that had been donated to the Greek Merchant Marines after the war because the Greek marines had been wiped out. It had been used for troop transport, so its entire hold was triple bunks. Fred and Stella were able to get tickets because of his prior work at the JDC; they had agreed that as part of his pay they would pay Fred's passage to North America.

When he and his fellow Central European refugees got on the boat in Genoa, they assigned all of them to the holds. Fred claims it was elitism that made him want separate accommodations — but it's not hard to imagine that triple bunks in the poorly lit hold of a ship would have felt eerily familiar to those who had bunked the same way in the camps. He went to the captain and negotiated what would have been $300 cabins down to $10 each so that he and Stella (and the others) had beds and privacy.

It took two weeks to cross. Fred jokes that the boat was held together by paint layers, chewing gum, and tape. But it got them to Halifax. From there, they were put on an old train with wooden seats that slowly made its way to Toronto.

They found Toronto to be cold in more than temperature. The Jewish aristocracy that existed there was not welcoming to refugees, worrying that the newcomers reflected poorly on all Jews in the country, thereby threatening their image and their place in the local social hierarchy. Fred and Stella had made it to the continent they wanted, but not the country, and the lack of welcome made them eager to move.

With little opportunity in Toronto, they quickly moved on to Montreal.

All the practicing English during their time in France paid off: because of their strong language skills, Fred was able to land a job managing a production line for an office supply distributor and Stella took a job working for a British banking company. He remembers little of Toronto or Montreal other than Stella's banking job where they quickly grew to trust her to count huge sums of money in a back room alone. She was not great at math, but Fred is positive that a dollar never went missing because of Stella.

They saved money and tried to figure out how they could get from Montreal to New York, the city they ultimately wanted to be in. They took a vacation together to New York to get to know the city so that they would be ready and know where they wanted to live as soon as the opportunity presented itself. Immigration quotas remained strict and Fred considered briefly either overstaying their visa or studying in a Jewish school to be able to trick immigration agents into thinking he was an Orthodox Jew, which might get them around the quota. He decided against both ideas: he wanted to move to the US honestly and legally. They had entered themselves in the immigration lottery as soon as they had gotten back to Prague; after seven years of waiting, their number finally came up.

UNTITLED DRAWING (Apartment in Paris), c. 1946

Ink on paper, 9.5 x 12.5 inches

UNTITLED DRAWING (Paris), c. 1946

Ink on paper, 12.75 x 17.25 inches

UNTITLED DRAWING (Williamsburg, Brooklyn), c. 1953
Ink on paper, 9.5 x 12.5 inches

These sketches of what Fred saw around him were a constant companion beginning as early as Terezin and continuing on for most of Fred's life. Notebooks filled with them moved from France to Canada to New York. Some were later destroyed by Stella, but many of Fred's earliest sketches still exist. Flipping through them, Fred pulls out themes that later become the basis for larger more intricate paintings.

Chapter 16

Something Seemed to Break (late 1950s-1960s)

Fred and Stella packed their minimal possessions and took their savings with them on a train to New York. They arrived in Grand Central Station and took a cab to a building where someone they had known in Paris had secured an apartment for them. It was in the basement of a building on East 70th Street. Fred couldn't live in a basement: too dark, too cramped, too claustrophobic. They had a little bit of money saved, and from their trip to New York, they knew of a hotel on 97th Street and West End Avenue. They moved to the tiny top floor walk-up, which had a terrace Fred could use as a studio.

Fred took a job in a factory as a production coordinator. He used his lunch breaks to sketch, mostly representational work of landscapes and Williamsburg, which he looked out at from the factory. Stella had an uncle outside the city and another who lived just up West End Avenue.

These uncles had sent care packages when Fred and Stella were in France. Fred wrote when they arrived but found himself mostly ignored. They would see the family occasionally, but Fred took it personally that they never offered to help. "We never would have accepted. But they should have offered." Helping out a refugee niece an ocean away was one thing; being the main support system for someone living just a few blocks from them was quite another. This was not uncommon at the time, and similar stories are not hard to come by. Stella's successful uncles and their families worked hard to keep distance between themselves and their niece. Fred wonders now if they sensed that Stella was depressed and frail and recognized the high level of care and support she might need if they engaged at all. I suspect they were more concerned about the potential financial drain supporting Fred and Stella could have become. Whatever the reason, Fred and Stella did not keep pressing her uncles, and instead focused on building a new community together on the Upper West Side in Manhattan.

Stella made connections in the art world; she was a good salesperson in many ways. The first significant sale she made for Fred was to an art dealer Stella had met who was selling large graphics wholesale. The dealer commissioned Fred to do an edition of 100 lithographs with six basic pieces: two landscapes, two seascapes, and two interiors. Fred became interested in the mechanics of lithography and quickly completed the full commission. Stella also connected with dealers sourcing artwork for doctor's waiting rooms and office buildings, and got Fred commissions to paint for those as well. Soon they could afford their first car, a Ford two-door, which was entirely impractical because it was impossible to load Fred's paintings into it.

Fred kept a meticulous address book and reached out to anyone he

had met in France or before who might be able to connect them to a community in New York. The American GI who dated Eva and who Fred met in Paris, Lou, had had a high school art teacher who lived nearby, and Fred started getting together with him regularly. John Taylor, another artist he met in Paris, wrote to invite them up to Woodstock. Fred found his factory work dull, but it left time for painting and his social life grew as those he met introduced him to others. He was mostly friendly with other Jews, though few of them were survivors (that he knows of — it was never talked about). The immigrant community seemed chaotic, and Fred liked order. He focused on getting to know Americans and artists as his main community.

Fred wanted to learn the history of their new home. Now that they had a car, he took Stella on a road trip to American Civil and Revolutionary War battlefields. Mostly he remembers being shocked by how much what he thought was a history of racism was still pervasive in how these historical stories were told.

Fred and Stella had arrived in New York without Eva. With their little remaining family refusing communication, Stella was desperate to have her sister nearby again. Fred learned of a need for experts in working with jacquard looms from a friend of a friend. These are complex interwoven threads made into patterns. In the mid-1800s, these patterns had to be stitched by hand, but by the mid-1900s, a loom had been developed to weave these complex patterns. They were operated by a long sequence of cards, similar to the punch cards that would be used in early computing. To create these patterns (both in design and using the cards) was a sought-after skill, and Fred convinced this friend of a friend that it was one Eva already had. She had never heard of it, but he wrote her letters detailing what she would have to do, and Fred secured

a "specialists" visa for her that got her around the quota system and into New York.

Unfortunately, when she arrived in New York and took an apartment a few blocks from Fred and Stella, Eva began to lash out at them. Whether she was jealous of Fred's devotion to Stella or pained by her own losses, Eva was critical of everything Fred and Stella did, right down to the placement of furniture in their apartment. She thought Fred should have gotten a different job, earned more money. He would have loved to go back to school — learning was always a passion for him, and with a degree, he might have been able to do what Eva suggested and earn more. What Eva did not know though, was that Stella's depression was becoming more severe. Fred was afraid to leave her alone. He quit his job in order to devote more attention to her, though he told friends and Eva that it was to focus on being a full-time artist.

There had been signs and struggles earlier, but in the 1950s, something in Stella seemed to break. In retrospect, Fred wonders if she had been

having an affair that ended. Their own physical relationship had fallen off long ago. She lay in bed for days while Fred tried to convince her to get up, go to work, and keep the routines that had saved them in the first few years after the war. Sometimes it worked, sometimes not. Fred went to the library to study what he could about depression. He started trying various treatments, but nothing seemed to help.

Still, there were good times. They flew to California together and travelled along the coast. The slides from the trip show two people happy and in love, exploring beautiful views and appreciating landscapes unlike any they had seen before.

"I remember very clearly being on the West Coast and ... [for] the first time in [my] life, looking at the sea with a straight horizon," Fred told his son Daniel, when Daniel made a film about the journey, "My First Wife Stella."[47]

When they arrived back home, they wanted more time at sea, and Stella convinced some friends living on Long Island to buy a small sailboat with them. The idea of having a boat had always interested Fred — being central European, it symbolized not being stuck or landlocked to him. They spent weekends with friends sailing the Long Island Sound. Fred read voraciously and learned everything he could about navigation and sailing, then put that learning into practice on the boat.

Stella usually got along well with other people, often hiding her mental illness from friends. But eventually it would catch up with her and she would lash out. As with most of the people in their life, she and the friends with whom they bought the boat eventually had a falling out, and whether they sold the boat or simply walked away from it, Fred does not remember.

ORANGE OWL, 1966/1970
Print on Heavy Rives Paper, 19.5 x 15.5 inches (print),
26 x 19 inches (paper)

ROUND OWL, 1966
Print on Heavy Rives Paper, 9.25 x 9.25 inches (print),
26 x 19 inches (paper)

Fred was bringing a few pieces to show at a gallery and got to talking with the gallery owner, whose young daughter, three years old or so, was running around, for which the gallery owner kept apologizing. When the owner got distracted, Fred called the little girl over:

"What's your favorite animal?" he asked.

"Owls!" she responded.

So he drew her an owl and gave it to her.

"Another!"

He drew her another.

The gallery owner came over and looked over his shoulder. "You're not giving her that. Do more, and we'll do a show of them," he told Fred.

Fred began drawing various owls, all similarly circular to the two above, with careful feathers and talons. The gallery did an entire show of the owls, which sold out. The owner asked Fred to do a second show, which he did, and the show sold out again. The owner suggested a third show, but Fred was "concerned that I would just become that guy who paints owls" if he did a third show and declined.

Nonetheless, many of his friends came to think of him as having a particular fondness for owls, and when they visited, would bring small owl trinkets — pictures, photos, stuffed animals. They take an entire wall in his dining room today and owls can be found throughout the house.

Chapter 17

Sinking
(1960s)

B y the time of the owl shows, Fred had long been home with Stella full time to keep her safe from herself and her depression. They were isolated from the friends they had made over their first decade in the U.S. Perhaps because of the release that his artwork gave him or simply because of the genetics of who he was, Fred had a greater store of resilience than Stella. He spent his days painting while keeping watch over Stella. Fred had managed to bring a few of his paintings from Paris with him and he noticed that they were already starting to crack.

Through a combination of the artists he was learning from and books taken out of the library, Fred learned that impure oil bases in oil paints made the work likely to break down quickly, and it was impossible to tell at home whether an oil-based paint was pure. Acrylic paints, which would allow him to mix his own pigments and wouldn't break down

as quickly were just becoming widely available, and Fred immediately switched over, purchasing the acrylic base and pigments in bulk so he could mix them himself at home. When he bought a powder, he would label the pigment with a color and number, and the year it was purchased. Those jars have moved with him for many years; some of these pigments have lasted over five decades, each one used in small amounts at any given time, each for a very specific purpose in a piece. Today they line his studio with their name and date, a physical display of his propensity towards keeping perfect records of everything he touches.

On her good days, Stella could still sell Fred's artwork to galleries. She would put on a nice dress and heels and waltz into the galleries to chat up the owners. Outwardly, she seemed to have a sunny personality, and the two of them having spoken only English for well over a decade meant her English was better than she liked to admit, which gave her a sophisticated European accent when she spoke to strangers instead of the sound of a new immigrant struggling to get by. Fred also began teaching Stella to paint. He gave her the basics of mixing and using paints and would stretch and prime canvases for her.

Stella's portrait of herself, included in the coming pages, stands in great contrast to the type of work she would sell. Fred now calls her flowers and landscapes "commercial" work. She painted them partially for herself but more because she knew she could sell them. On good days, the two of them might spend an entire day in their studio, the second room of their apartment, back to back, painting. Creating beauty out of the trauma of their shared history.

On bad days, Stella tore things apart instead of creating them. She burned Fred's meticulous records of their work, believing some of it

might link to their Jewishness, and put them in danger. She destroyed many of his earliest works, ransacking the studio. Once she attacked Fred with a knife, then another time with a pair of scissors, afraid that enemies would find her because of him.

Victor Frankl's book, at the time called *A Psychologist Experiences the Concentration Camp* but since retitled *Man's Search for Meaning*, was one of the early attempts to study the psychology of those in the camps. It had been published in German in 1946 but was not translated into English until 1959. This was the first look specifically at the psychology of survivors and focused on Frankl's own school of psychology: logotherapy. Through a friend, Fred heard of logotherapy, which focused on finding meaning in suffering, and found a doctor to try it with Stella. He remembers the sessions as unpleasant. One of the long line of treatments Stella underwent, logotherapy seemed to make things worse instead of better.

In some part, the challenge was that no one recognized, let alone understood, all that Stella had been through. Today, she might be diagnosed as suffering from Post-Traumatic Stress Disorder. At the time, the term "shell shock" was going out of style and was believed to only happen to soldiers. Another term, "survivor syndrome," had just been coined. What little psychological research was being done at the time was arguing about whether a survivor's symptoms were more about what had happened in the camps or more about pre-existing conditions. Early work found that almost all survivors had some serious mental disorder after liberation. Over the following 20 years, a consensus would emerge among those studying survivors that "the severity of mental disorder correlated with the severity and duration of the concentration camp experience," more so even than pre-existing conditions.[48]

Little looked at how pre-existing conditions and in-camp trauma intersected. Fred speculates now that her trauma was combined with some version of bipolar disorder (at the time, manic depression). Stella's mind attacked herself and Fred from the inside out. Fred's role as caretaker grew; he was afraid of what his wife would do if left alone. He had one friend who he trusted to stay with Stella when he was out to ensure she didn't do something to hurt herself, and he would run errands when the friend stopped by.

Over time, most days became bad days. Fred continued to search for treatments at the library but was beginning to worry he couldn't care for Stella the way she needed. He came home one day to find her sitting in the kitchen with the gas of the oven on. Whether she hoped to be found or she hoped to die, he doesn't know. He turned it off, opened the windows, and brought Stella to see a psychologist again, who spoke to Fred after meeting with Stella. (It was not uncommon for women to be excluded from decisions about their own treatment, and this was no exception.)

"She is going into the hospital."

"Why?" Fred asked, "She doesn't seem any worse than a few months ago."

"Yes," the doctor replied, "but you are sinking."[49]

Fred needed a break from constantly caring for and worrying about Stella. They checked her in. It was the beginning of a long string of hospitals, many of which Stella would check herself out of after only a few days, sometimes running away, sometimes returning home to

him. He researched and tried everything he could find. One hospital tried electroshock therapy — Fred thinks there were only two or three instances of it. He is defensive in telling me about approving this, explaining that he didn't like the theory, but it was the best they knew at the time. He stopped it because it seemed to aggravate her and make her general thinking more muddled.

Much of Fred's early art career can be traced to Stella's mental health needs. He looked for things to take up their days when she was not in the hospital and settled on creating prints together. Hardly intellectual equals, they needed something to do with their hands to keep busy, and to keep Stella from succumbing to the desire to kill them both. Creating a high-quality print was absorbing work that required two people. A single print could take a full day, which made it perfect work for Fred and Stella when they were spending weeks on end together in their

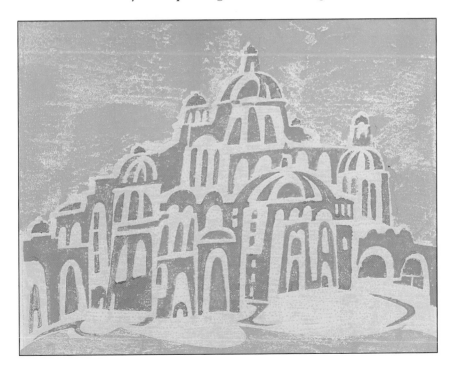

apartment. They built stamps out of Masonite together, then using water soluble paint, would add one layer after another to the print. Each color has to dry before another layer can be added, then the stamp itself has to be perfectly aligned with the first pressing for the print to come out properly. Fred and Stella made dozens of prints together; it gave them months of activity, and each day's work ended in something that could be sold. *The Pavilion*, which appears on the previous page is one of the prints that Stella and Fred worked on together, which was made in 1967. Fred used the gallery contacts Stella had established in order to sell them, mostly to pay for medical bills as Stella became more disturbed.

When he woke up in the middle of the night to her standing over him with a heavy paperweight, he rolled out of the way before she could bring it down on his head. After that, he checked her into the hospital again and asked the doctors what could be done. They prescribed medication, and sometimes she would stay on it for a little while after being discharged, but other times she would stop. The 1960s passed this way, and Fred remembers little of what happened over the course of it besides Stella's attempts to die or kill him, and his own attempts to keep both of them alive. The volume of artwork they were creating increased dramatically.

Fred took Stella to try new therapies, sometimes going with her if that was the treatment protocol. Gestalt was among the ones he still thinks about and regrets. Gestalt therapy takes many forms; in some, patients are asked to enact traumatic memories of the past and respond to them in the moment to try to reframe how they experienced and responded to the trauma.[50] Group models of Gestalt therapy were fairly normal, and Fred recalls Stella attending a number of them, with a sort of hot-seat structure where each patient would sit in the center and interact with the

therapist, then the rest of the group would respond. Like logotherapy, Fred felt it was making Stella worse instead of better.

He heard rumors about another doctor: Miracle Max or Dr. Feelgood. Dr. Max Jacobson is now known for seeing celebrity patients on the Upper East Side in New York and injecting them with amphetamines.[51] In the waiting room, Fred and Stella met actress Heddy Lamar, who they would sustain a friendship with over the next two decades, trading support when it was needed. Injections from Dr. Jacobson would help Stella for a few days — Fred tells me she would arrive "absolutely raving. He gave her a shot and it was like he'd thrown a switch. Suddenly she was a nice normal person." At one point Fred tried an injection as well for pain in his side. Similarly, it helped for a few days, then the pain came back. Their experience with this treatment was relatively short-lived. Jacobson eventually lost his license.

During the periods of time Stella was in the hospital, Fred dived more deeply into the Jewish community. He still felt a pull from those he had made a pact with in the camps to share their stories, and after the public trial of Adolf Eichmann in 1962, the world finally seemed interested in listening. Their apartment was near the 92nd Street Y in New York, and over time, that had become the center of Fred's social circle outside of Stella. A friend there told him that there was talk of opening a Jewish history museum in New York, and he became involved in exploring that. Through those connections, he was asked to speak to high school students about his experiences in the camps, and he started to find himself on a speaker's circuit.

He felt then, and it continues today — Fred is 96 as I work on this final draft, and he is still appearing and speaking in public — an obligation

to tell his story as a way to memorialize those lost. There are so many who could be forgotten. It's impossible to know what they could have done had they been allowed to live, and Fred comments to me in passing during conversation that perhaps the person who could have cured cancer or written the great symphony of the 20th century perished alongside his friends and family.

He never asked for a speaker's fee, only for funding for transportation to get him to these classes. His speaking engagements created a self-reinforcing cycle: the more he learned about Jewish ideas, the more he could speak on them, the more they wove into his artwork, and the more interested he became in learning more. He continued to paint landscapes and other work that he knew would sell, often signed with the false name Anret (Terna backwards) but also began giving himself the freedom to use painting to "express the unexpressible."

In the early 1970s, Eva convinced Stella that it was Fred who was causing her outbursts. She felt strongly that Stella and Fred should not be married, and Stella eventually complied and asked for a divorce. She moved into her own apartment, where Fred checked on her daily, continuing to serve as her main caretaker. He arrived there one afternoon to find her missing. She was not with Eva or any of their friends. He filed a police report. She was found a few days later in Florida, with no recollection of how she had gotten there or what she was doing. He asked the police to put her back on a plane and they sent her back to New York, where she checked into a hospital for an extended stay.

It was not the last time this would happen. Fred got phone calls from hospitals, telling him she had arrived, she needed clothes, she had no shoes on, they needed an address to send the bills. They asked him

to bring her underwear to the hospital, she had none. The drawers in her apartment were empty and he would have to ask what size she was before buying some.

Medical bills piled up: $12,000 to this hospital, $3,000 to that one. Fred called to negotiate the bills down, but still, his work as an artist was not enough to pay for her hospital stays and two separate apartments. He struggled to stay afloat under the weight of it all. The German government was offering reparations. They were inadequate, of course, and Fred did not want the money. What amount could make up for what he had been through? But he swallowed that pride when he realized how much care Stella needed and began the long, arduous process towards receiving payments.

The first stop was at a German embassy, where Fred waited for hours, then was eventually called into the office of a man about his age, Hans, who had been injured during the war. He seemed so familiar; if they hadn't grown up together, they could have. They talked about being European immigrants in New York, about their mutual enjoyment of art and classical music. They even touched briefly on their experiences during the war. Eventually the man's supervisor came in and reminded him that there were dozens more people waiting. They decided to meet for a drink when he got off work. To Fred, the fact that this man had been in the German army during WWII was irrelevant. It was not a matter of forgiving the soldier, who had no more control over his environment than Fred had. They became friends and stayed in touch for years.

Fred was eventually approved for reparation payments, which he used to pay Stella's hospital bills.

STELLA HORNER: UNTITLED (Self portrait), c 1960s
Acrylic on canvas, 14 x 14 inches

STELLA HORNER: LANDSCAPE, 1960
Acrylic on canvas, 18 x 24 inches

STELLA HORNER: UNTITLED (Watercolor), c 1960s
Watercolor on paper, 12 x 18 inches

In Daniel's film, "My First Wife Stella," Fred says "Stella was an emotional person. She started doing watercolors and sketching. She developed a very personal way, totally undisciplined artistically. Just pouring out emotions. Her emotions were spontaneous, just straight from the soul. Not cerebral as mine are."

The first painting here is Stella's self-portrait, the second is one of her landscapes, and the third a watercolor house. They are each beautiful, and each more directly representational than the majority of Fred's own work.

Chapter 18

Connecting Anew
(1960s-1970s)

Fred started to look for companionship, something he had missed for many years with Stella, both as her husband and as her caretaker. Through a friend, he was introduced to Caroline [name changed], who was an office decorator, on the pretense that she may want to buy a few of Fred's pieces. Caroline was married, but her relationship with her husband was more platonic than anything, and he approved of her seeing other people. I asked if Caroline's husband was gay, and Fred says he doesn't think so. His best guess is that Caroline's husband was asexual; they had companionship and a family together, but he never expected her to see only him. She had two daughters, one by her husband, and Fred believes the other by another man, who likely did not know he had a child.

Over the course of years, Fred saw her through a break-up with the other man, and their fondness for each other grew. They began to date. They

had coffee, then lunch, then dinner. Their relationship turned physical. She felt more like a spouse by then than the hospitalized Stella. Fred and Stella's physical relationship was over; their years together left him feeling obligated to be her caretaker, but they had little else in common.

Caroline was an intellectual equal for Fred, something he had never had in Stella. She was in the US during WWII and so had gone through her formal education uninterrupted. She was particularly fond of English literature, but they could talk about anything, and Fred found himself challenged for the first time.

She introduced him to her husband, and shortly thereafter to her mother and daughters, all of whom seemed to accept his presence. Her husband was not handy, but Fred, who lived simply but had never had much disposable income, was in the habit of fixing things himself. He went over to fix a leaky faucet or check on a broken light fixture. The family grew used to having him around. She made up a perpetually ill friend to explain to her daughters why she was occasionally out for nights or weekends at a time.

The two of them subscribed to the Metropolitan Opera. They went to plays, concerts, and lectures. They became regulars together at the 92nd Street Y, and Caroline introduced Fred to her synagogue, which they would attend together. Though most of his friends were Jewish, Stella's fear had kept them from being too much a part of the Jewish community. He began, now, to find those links for the first time, going as far as to join a synagogue. Having grown up in the United States, Caroline had no reason to fear religion.

Through their connections at synagogue and at the 92nd Street Y, Fred

was asked to curate the art in the display cases of a building owned by the nonprofit United Jewish Appeal. It was not a paid gig, but through it, he deepened his connections to the art community across the city. Perhaps through that or maybe through another connection from his lecturing, Fred was asked to teach a course at The New School about Art in Jewish Life. With Caroline's support, he embraced these opportunities, which were in some way a rebellion against Stella's decades of hiding their Jewishness. He created a series of slideshows. When we talk through them, he emphasizes to me that there is no such thing as Jewish art, just art with Jewish subjects or art made by Jewish people; the art itself is not inherently Jewish. Caroline's companionship gave him permission for this kind of exploration.

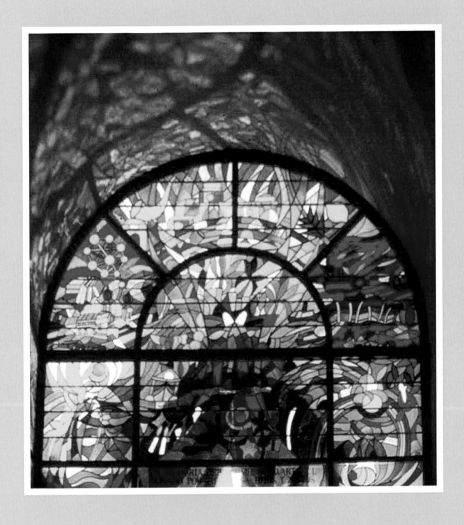

STAINED GLASS IN PANAMANIAN SYNAGOGUE, UNTITLED, 1991

One of only a few pieces of stained glass Fred has created, this one for a synagogue in Panama, tells a variety of biblical stories using the same shapes and color schemes seen throughout his work. The center, lower rectangle includes symbolism for the

seven days of creation (separating water from that above; light; dry land and vegetation; sun, moon, and stars; fish and fowl; land creatures and Adam and Eve; and candlesticks for the Sabbath). The right square has three biblical stories: Noah's Ark with a dove and the first rainbow, Jonah and the big fish, and the parting of the Sea of Reeds. The center upper arch has the delivering of the ten commandments on two tablets on Mount Sinai, as well as a portable sanctuary.

Chapter 19

Stepping in to Answer (1980s)

Fred's relationship with Caroline and her family continued to deepen. Caroline and her husband had power of attorney over his estate, and he over theirs. They travelled together, made plans together. But some amount of it, no matter how strong love was between the two of them, felt make believe. What she offered him was not a full life. She spent nights or weekends with him, but at the end of it, he still drove her back to her husband and children. And each time he did, Fred's heart broke just a little bit on the drive home. On top of that, the Holocaust remained central to his work, and he needed someone to understand that. Caroline knew, of course, and helped encourage him to speak out, but she was a third generation American. It wasn't in her bones the way it was in his. Another decade passed, which in the retelling lacks clear memories except the simultaneous feelings of comfort and heartbreak around Caroline and the continued care that Stella needed.

He began spreading news among his friends that he wanted to be married again. He wanted someone to find him a wife. She had to be nice, bright, and preferably Jewish. He did not want to explain the Holocaust to a woman he was dating, she simply had to know. He had coffee with every friend of a friend that anyone suggested.

Fred discovered he did not really know how to date. He and Stella had been together as children, and he and Caroline had fallen into bed together after cultivating a deep friendship. He had coffee with a woman, then dinner. Then he didn't know what to do. He took a class and learned to make Indian food. If the first two dates went well, he asked the woman to come over for Indian food. It was specific and different enough to make him interesting. He started making all kinds of fruit-based chutneys as he continually had women over for third dates. But none of the women filled the void in his life. And it was becoming increasingly difficult to explain his role as the main caretaker of his troubled ex-wife who continued to move between hospitals and her own apartment, where he would stop in to look after her. Not everyone could understand his tie to her.

On March 21, 1982, Fred was speaking at a conference for the children of Holocaust survivors, called second generation survivors. The second generation was old enough now to have children. Though as second generation, they had been trained never to ask, the third generation had questions, and Fred was stepping in to answer them; with what had been Caroline's prodding originally, he had over a decade of experience telling his story now. He left the conference and walked to the #6 train, where he ran into one of the conference attendees, a child of two survivors, Rebecca Shiffman. He introduced himself.

"Where are you going from here?" he asked.

"Uptown," she said.

"Me too," he responded. "May I ask you a rather brash thing? Do you mind having a cup of coffee?"

Rebecca agreed and their first date happened on the spot. Looking at the starving artist in front of her, she even paid.

When Fred got home that night, he called his friend Larry. "Larry, I found her! I found my wife."

"What do you know about her?"

"Nothing," said Fred, "except that she's the right one."

It didn't take long for Fred to confirm his intuition. Thirty years later, he still has chutneys from those days in their cupboards. They are set up almost exactly like his paints two stories above: glass jars with labels describing their contents and the date created. The last jar is dated right after he met Rebecca. His wife found, he no longer needed to make Indian food. Rebecca was a medical resident at the time, clearly bright and sharp, and also incredibly kind. She had been born in Paris but raised in Bogota, Colombia. She moved with her parents to Boro Park, an Orthodox neighborhood in Brooklyn, NY when she was 12. She remained an Orthodox Jew until her junior year of college, when she was studying abroad in Israel and became disenchanted with religion. Fred introduced her to his reform synagogue when they met, but while she understood Fred's connection, and all this community had done for him, Rebecca could not find comfort in the reform movement.

Rebecca's first gift to Fred was the complete Encyclopedia Judaica; learned herself, she encouraged Fred to continue studying if that was what he wanted. Soon after they met, Fred gave Rebecca a key to his apartment. Five months after their first date, in deference to Rebecca's family's preference, they married in a traditional Orthodox ceremony.

He continued to visit Stella, now in the hospital most of the time, and Rebecca respected the space Stella would need to have in their new family. He had no legal say over her care, but by now, there was no one else left to care for her. Eva had committed suicide; the police who found her had called Fred first, and he was the one who had to tell Stella. Fred says, "Many people preferred suicide. I'm removed from that. And the answer is that I have an obligation [to tell this story]. It overrides other things."

Stella told Fred at one point that she had found a large lump in her breast, but she refused to have it examined. By the time she had a physical and was hospitalized for it in February 1983, it had metastasized.

In March 1983, Rebecca and Fred travelled to Israel for a belated honeymoon. Together, they chose gifts for Stella, things to decorate her hospital room with, little trinkets with her name printed on them. They received a message at their hotel the night before their return flight. Stella died on March 23, 1983. Fred felt her death was a suicide by neglect; if she had cared for her body, she might have lived.

Fred and Rebecca returned and arranged for the funeral together. Like her sister, Stella would be cremated and her ashes kept in a mausoleum.

[TITLE REDACTED], 2012
Acrylic and aggregate on canvas, 24 x 18 inches

In 2012, Rebecca had an incredibly unkind boss. She would yell at Rebecca for things that weren't her fault and blame her in front of superiors for things outside her control. Other obstetricians were quitting left and right, and Fred was outraged. Of all the things he has experienced in life, the idea of someone being so mean to Rebecca was unbearable. His feelings opened the door to a series of pieces like this one, which attempt to paint evil. There are three canvases in this specific series, each of which is titled after Rebecca's boss, whose name is redacted. Overall, the pieces bring Fred back to some of the early subjects of his work, filled with dark, painful colors and patterns that, with the safety of being loved by Rebecca, he is able to explore once again.

Chapter 20

The Art Speaks (1980s-2000s)

With Stella's death, life calmed. In October of 1983, Rebecca became frustrated with the apartment in Manhattan. It was too cramped with all of Fred's art supplies. They considered renting a studio space for him, but there was nothing he liked, so they decided to move into Brooklyn, where they could afford more space. They were outbid in the up-and-coming neighborhood of Park Slope, and eventually found a large brownstone in the Bedford-Stuyvesant neighborhood. It would be decades before gentrification started in the neighborhood around them.

The interior of the house was painted garish colors, and while Rebecca finished her residency and worked toward a career as an OB/GYN for women with high risk pregnancies, Fred repainted the house in bright whites, set up what furniture they had, and transformed the top floor into a studio for himself. There were still coal bins in the basement, and

a dumbwaiter that went through the whole house.

He began to speak more frequently about his experiences, about his life BR — Before Rebecca. Where many survivors found themselves struggling to find a way to express themselves, Fred delved deeper into his art, allowing art to speak for him when it could, and using it as a lens through which he could view his life and experiences.

As he got older, it would take longer to recover emotionally from delving into his past. When I ask Fred, then in his early 90s, how he recovers, he tells me this: "There is something called habit. A daily routine. I wake up at 6:30 and go through a ritual. You get up in the morning and do things nearly automatically. There is a sequence between washing, brushing your teeth. We all live by routine, a healthy thing if it's a good routine. It's mechanical. Even painting, there is a certain routine in clearing my desk, having the proper paint surface, spreading the palette knives and pigments. After I'm done, clean the palette, clean the palette knives, close the jars. There is a routine to the day and I think that routine is very useful. Normal life. The little pesky details are very important. They give life continuity. The notion of the past overtaking is a very dangerous one. I was aware of it from the beginning. I don't have to be tortured by these memories." This order of routine works for Fred, and it can be seen everywhere: early on in his work as a bookkeeper in France, but also in big and small ways today: the perfectly kept art records, the chutneys in the kitchen, the pigments on shelves in his studio. All of it is about a sense of order and a sense of control over what will happen and what to expect.

The tenor of living with Rebecca is that of companionship. Affinity. A complete comfort. Fred did not feel he needed to explain his past to her.

Rebecca understood and accepted the needs that came with being with a survivor: continuity, no disturbance, boredom. Decades pass with little that stands out as particularly important to Fred to share with me. There is a predictability of relationships. Fred and Rebecca function entirely in conjunction with one another. Fred says of their being together: "I don't worry about Rebecca...She is doing very important work. She does not need to prove to me that she is a valuable and respected member of the community, it's a given."

The only place they occasionally disagree, he says, is when it comes to religious matters. Fred has very little respect for ultra-Orthodox Jewish culture that Rebecca also rebelled against as a teenager and never really went back to. He accepts being part of it as part of Rebecca's clan, attending services in an uninvolved way, approaching it more as an anthropologist than with kinship. Despite how incredibly knowledgeable they both are about Jewish topics, both of them insist they don't particularly believe in religion. They find a balance at Kane Street, the synagogue I grew up going to, which is progressive conservative, and provides a relatively traditional service but places equal value on men and women in the community. When I try to press Fred on the tension of both disliking associations with organized religion while regularly attending synagogue and lecturing on Jewish topics, he shrugs, and tells me he just goes where he feels comfortable. I ask this question in different ways for years and never really receive a satisfactory reply.

Fred never planned to have children, but he knew Rebecca wanted a child. He doesn't recall having a direct conversation about whether they should try. It was natural to him that if Rebecca wanted something so badly, she must be right; Fred did not question this. He knew they were physically prepared for a child, they had the space and the money, and

they began to try for a child naturally.

Fred was in his 60s, and Rebecca in her early 40s. They struggled to conceive. After her fourth miscarriage, they were both too raw to try again, and decided to adopt. They began telling friends, and running uniquely in a circle of people who worked with high-risk pregnancies, it was not long until a friend of Rebecca's asked if they wanted a baby: a patient was looking for someone to adopt. Rebecca asked Fred.

"Yes, if it's a girl," he replied.

"It's a boy," Rebecca told him.

"Alright, a boy then."

They battled through a quick adoption in time to get Daniel home for a brit, the Jewish ceremony of circumcision that takes place eight days after a baby boy is born.

Rebecca continued to work, and Fred would take baby Daniel to galleries with friends, and parties in Manhattan. He had less time to paint than before with a baby and a large house to care for. They sent Daniel to Jewish schools. As he grew, he became aware of his father's history. Like many with relatives who are survivors, there was no specific time when it first came up, simply the feeling that one has always known somewhere in the back of one's mind that this family history exists. It was challenging for both of them; Fred was older than many of Daniel's friends' grandparents, and their relationship struggled under the weight of Fred's history. Fred could not run, or play catch the way other fathers could. Daniel bristled when people talked about his father

being "in good shape for his age," and wondered why he could not have a "normal" father.

Fred gave me a stack of private year-end letters from this time, typed and sent to friends and family to share what they have all been up to. The annual letters from 1996-2008 show the routine of their life: Fred and Rebecca were in two book clubs, one focused on new novels that Fred did not enjoy but attended anyway for 20 years, and one on weightier subjects that was more to his liking. A discussion group of friends meets 10 times each year and members present on various topics that interest them. Fred and Rebecca subscribed to the Metropolitan Opera, to a series of chamber music concerts, attended lectures, and visited museums.

Throughout the letters, Fred goes into detail about Rebecca's illustrious career without writing much about his own aside from the occasional note that he is teaching a teen paper-cutting class or lecturing about his works. He chronicles Daniel's childhood and teen years, noting the times he leaves for school each day, piano lessons, hockey practice, skiing, or snowboarding with Rebecca.

The year that is most unusual is 2001, when Fred recounts the impact of September 11th on their family, writing:

> *September 11th came and the city, the country, and the world changed. That day, while walking in Brooklyn, fine ash was falling, and the air reeked of burning. Brown billowing smoke drifted across the East River from Manhattan. Fifty-seven years ago, in Auschwitz, brown billowing smoke from the crematorium chimneys rained ashes of murdered people on me, and the smell of burning was fraught with horror. My recollection was immediate. Feelings that over the years*

had softened their contours surfaced with cutting outlines...

My first reaction was practical. I called Rebecca at work...I called Daniel's school and made sure that he could get home safely. Since bridges and tunnels to Manhattan were closed, I suggested that boys from Manhattan could stay in our home, and two of them joined us. Without knowledge about the extent of the destruction I went and bought three gallons of drinking water. That was all.

I read these lines with wonder that Fred, who had experienced raining ash and the purposeful burning of bodies before, did not have a more immediate and visceral reaction to the event. Perhaps having a son and his friends to care for gave him a way to focus and ground himself. Perhaps he simply had the confidence that anything can be survived.

<center>***</center>

In Jewish schools, the Holocaust came up. Many of Daniel's classmates were third generation survivors, meaning their grandparents had survived the camps. Daniel's combination of being second and third generation is unusual. When Daniel's class was sent home to talk to grandparents and friends about their experiences, Fred found that few of them were getting real answers. He encouraged the school to try to pull resources together. They struggled and eventually launched an archival team, which Fred joined. Through that, he wrote about 15 vignettes about his experiences, quoted throughout this work. In 2001, he includes in his letter that he continues to be on the Archive committee, where he is the only survivor in a conversation about how to teach about the Holocaust. "I usually remain silent during these deliberations. I'm not sure how, and at what age to impart such information to children. I'm careful. My words carry far too much weight in the gathering."

There are still vestiges of the camps in their home. In addition to Fred's artwork that hangs throughout the house, Fred's need for order pervades everything, even the studio that at first seems chaotic, but in which each book and binder is meticulously labeled with name and date. Though it is decades later, he has an escape route planned wherever he is and, as noted earlier, freezes up in the presence of police officers or other authority figures, taking a moment to remember he is not in danger here. His life having been saved more than once by a good pair of shoes, he still refuses to throw away shoes that are worn out lest he find himself without a spare pair should he need them.

He likes to know where his family is; I came to realize eventually that Rebecca's calls every hour and a half during our conversations are as much about him checking on her as the other way around.

This need for information and control was a challenge for Daniel as a child; teenagers don't enjoy constant worry. Daniel said in an essay that he wrote in college, "It was in high school that I eventually learned to feel guilty for not thinking about my father's emotional scars, like forgetting to call home when I stayed out late. My father knew family and friends who also stayed out late, but never returned."

Fred's annual letters show him vigilantly watching for signs that things might get worse: when Daniel nears 18-years-old, he worries about the potential for a draft to supply soldiers for the war in Iraq. He comments on politics of the day mostly in passing, but in 2008 says "Finally, years of malevolent greed, stupidity, and lust for power are coming to an end. The disasters of the past eight years will take years to overcome...There are a few more weeks before the Obama administration is sworn in, and that will have to be the good beginning for the letter about 2009."

After college, Daniel eventually moved back into the basement apartment in his parents' home, and he and Fred found equilibrium for the first time. Daniel took up photography, picking up an art form Fred still associates with his long lost brother, and started a small art gallery in the basement apartment. It's too modern for Fred's taste, and he doesn't really understand it, but he enjoys that Daniel enjoys it. Daniel's girlfriend stops by when Rebecca is out of town to check in on Fred and to offer to pick up anything Fred needs. Fred declines most of the time; his errands are a necessary part of his daily routine.

In 2014, Fred received an email from a young man in Prague. The man's grandmother, Zdenka, had just died, and since then, he had decided to track down Fred. At 16 years old, Zdenka and Fred's brother Tommy were secretly dating. She was not Jewish, and quite safe from the laws that endangered the life of her boyfriend. They saw each other clandestinely, and when it became clear that he was likely to be shipped out of Prague, Tommy gave Zdenka his harmonica to remember him by and to hold for him until he returned. After the war, she looked up his information and transport numbers and figured out how and when he died.

Tommy became family lore in Zdenka's home. The young man's impression, or perhaps what he was told directly, was that if the war hadn't intervened, Tommy would have been his grandfather; Zdenka remembered Tommy as one of, or perhaps THE, great love of her life. Though she learned late in life that there were transports with survivors and that Fred lived, she could never bring herself to contact him, or to share her memories. After Zdenka died, her grandson thought Fred might like to know the truth: Tommy had been happy before he was deported and was remembered by someone outside the family.

He tracked Fred down, wrote him an email, and eventually came to Brooklyn to visit, bringing with him as a gift the harmonica, the one belonging of Tommy's that survived the war. Having waited 70 years to hold something that once belonged to his father or brother, Fred keeps it to show me, then donates it to the United States Holocaust Memorial Museum. Let them display it; after all, it's only a thing, he intimates without having to say the words.

"The Tommy I remember is an inquisitive, enterprising, courageous, inventive, fearless, and lovable 14-year-old, yet at the same time a textbook teen-ager. He graciously tolerated me, and the grown-ups around him. To me he is still my kid brother, still 14 years old. At times I wonder what his life would have been like, if he had survived the Shoah. Today he would have been over 72 years old. In my heart he is still 14."[53]

<p style="text-align:center">***</p>

In his day-to-day life, Fred still shops like a European: daily, and in small amounts. It is both out of habit and to give him a task that gets him out of the house each day. The clerks all recognize him as he picks up the few things he needs. He eats the same lunch every day, a small piece of bread and cheese, a few grapes. "When you have starved," he says, "food is about sustenance, not about taste." Still, he is never disappointed when I show up with a mid-afternoon snack for us to share and when I tell him that an artisanal doughnut shop has moved in around the corner, he both complains about the gentrification of the neighborhood and asks where he can find it.

A true New Yorker, Fred takes the train everywhere. Unlike others

though, he strikes up conversation with those around him. He meets musicians when he asks about their instruments and actors when he sees them reading obscure Shakespeare plays they are acting in. He invites them for dinner. Rebecca cooks.

In 2015, Fred is invited back to Dachau for the 70th anniversary of his liberation. His 70th birthday, as he counts it. The invitation includes airfare and hotel for himself and an escort; it is a chance to show Daniel what he lived through in person. At first not inclined to attend, Fred ultimately accepts the invitation. He and Daniel travel to Germany together for one week, on a visit carefully curated to include times for solemnity and mourning and time for celebrating the lives survivors have

Photo by Adam Kremer

been able to live. In his writings reflecting on the event, Fred says "I have rather strong opinions about Germans living today. I'm careful about my preferences, my likes, and dislikes. I was careful in the past, as I'm now, not to condemn an entire group. I would not copy Nazi ideology. I do not hate, and I did not hate. Hate is self-destructive."

Daniel takes over Fred's promise to share the stories of those who died, and one person in particular who survived, arranging television interviews, and photographing what he and Fred experience together. When they arrive home, Daniel steps into the role of agent and curator, arranging exhibitions of Fred's work, negotiating sales. He coordinates with the United States Holocaust Memorial Museum in Washington, DC, which acquires about 25 of Fred's pieces, helping his father gather and label them, ensuring the legacy of his father's work.

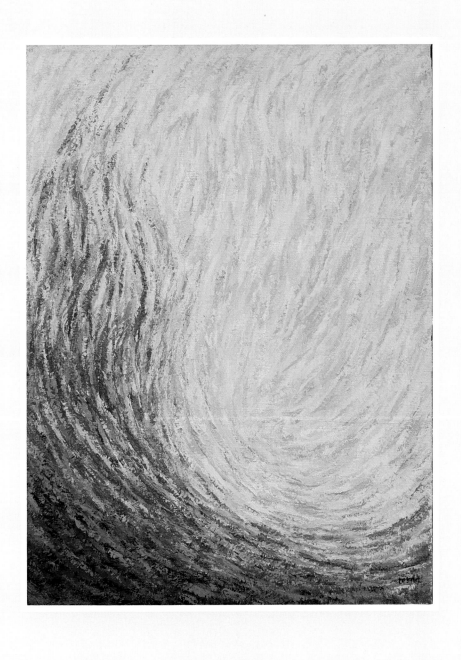

SHARED MEMORY, 2009
Acrylic on canvas, 24 x 18 inches

When Fred completed this piece, he immediately knew it was meant for Daniel. It had started as an intellectual exercise combining darkness and brightness, good and bad, past and present. Most of his earlier work is one or the other, but in this piece, he combines the two. "It's a painting. It hints at this or that, but it's for the person who looks at the painting to get some of that feeling...If I talk, I want someone to listen. If I paint, I want someone to look."

Epilogue

It is 2017, and I visit Fred to review an early draft of this book. Donald Trump has recently taken the presidency and it is hard to ignore the political climate hanging over our heads. I ask Fred what he thinks of President Trump.

"My first reaction to Trump was I'm back in 1932. With all the consequences of Hitler coming to power, the same idea that the scoundrels will go down the drain. The difference is the March on Washington, the march in Boston. A judge saying you can't do that. Those things weren't there then. It makes me feel somewhat positive. You're living through a situation that's quite familiar to me, with all the consequences. You're a reporter of what's going on in the world today. You're looking back and seeing something you recognize. I see the various military scoundrels doing their thing. They're stock figures, repeating."

"There are patterns to the world," Fred tells me. Nothing repeats itself exactly, but there are templates the world follows, and this is one of them. "The fundamentalist, fascist, supernationalist are well established patterns. They don't repeat themselves exactly. [But] the big picture was there and is here today."

I admit that the parallels between what I'm writing and what I'm seeing in the world are preventing me from sleeping at night. On the bright side, Fred reminds me, it is possible to live through it. I'm not sure I find it reassuring. The world rebuilds itself. This project has taken on a new importance for me, though I can't tell if it has for Fred, so I feel compelled to point out that it's more important than ever that he teach people how to live through it.

Fred insists over and over that we will get through this. This will not be the end of the United States experiment. But he does at one point concede that he doesn't think he will live to see us recover.

Right after inauguration, Fred tells me he's had trouble painting. It's happened before; in contrast to my work, where I feel galvanized by what I see around me, he is simply too upset to put brush to canvas. A few weeks later, he moves past it and begins painting again.

When he tells me this, I ask Fred what he is working on and he takes out an old piece he is revisiting. I ask what he sees in this one, and Fred points to a certain shape that appears a few times in the painting: "When I started this painting a few years ago, these looked like gates to me. Now they look like tombstones." We contemplate the painting together for a few minutes, until he moves the piece to the side; there is another painting he is still working on: there are more stories to be told.

Endnotes

[1] August Stevenson, Ed. *Oxford English Dictionary, Third Edition*, Kindle edition location 237265

[2] Murray Whyte, "An Emerging Art Star In Her Late 60s, Vivian Suter Brings Bright, Blissful Works to the ICA," *Boston Globe*, 29 August 2019, access re-confirmed 5 July 2020, https://www.bostonglobe.com/arts/2019/08/29/painter-vivian-suter-emerges-from-decades-self-exile-with-bright-blissful-works-ica/qN84uLL2lxT5zkIPfbEAyM/story.html

[3] Chad Bryant, *Prague in Black: Nazi Rule and Czech Nationalism* (Cambridge: Harvard University Press, 2007), 22.

[4] Bryant, *Prague* 51

[5] Fred Terna, "A Sixteenth Set of Notes for the Shoah Archive of the Abraham Joshua Heschel School," 20 December 2002

[6] Bryant, *Prague* 101

[7] Bryant, *Prague* 134

[8] Bryant, *Prague* 34

[9] United States Holocaust Memorial Museum, "A Leader Marches Czech Jews to Work in the Lipa Farm Labor Camp," photo, c. 1940-1942, taken in Havlickuv Brod, [Bohemia] Czechoslovakia, access re-confirmed 5 July 2020, https://collections.ushmm.org/search/catalog/pa1176221

[10] Bryant, *Prague* 118, 121, 137

[11] Fred Terna, "A Third Set of Notes for the Shoah Archive of the Abraham Joshua Heschel School," 26 October 1998

[12] Graham Melville-Mason, "Obituary: Karel Berman," *The Independent*, 25 September 1995, access re-confirmed 5 July 2020, http://www.independent.co.uk/news/people/obituary-karel-berman-1602823.html

[13] Bryant, *Prague* 173

[14] Bryant, *Prague* 150

[15] Bryant, *Prague* 209

[16] Fred Terna, interview by Gerry Albarelli, *September 11, 2001 Oral History Narrative and Memory Project*, Columbia University May 2 and July 16, 2005

[17] United States Holocaust Memorial Museum, "Theresienstadt: Red Cross Visit," Holocaust Encyclopedia, access re-confirmed 5 July 2020, http://www.ushmm.org/wlc/en/article.php?ModuleId=10007463

[18] Discussed on tour of Yad Vashem, the Holocaust museum in Israel, 12/28/2014

[19] Hilary Helstein, "As Seen Through These Eyes," film, 2009

[20] United States Holocaust Memorial Museum, "Kaufering," Holocaust Encyclopedia, access re-confirmed 5 July 2020, http://www.ushmm.org/wlc/en/article.php?ModuleId=10006171

[21] Albarelli, *Oral History*

[22] Bryant, *Prague* 3

[23] Bryant, *Prague* 179-186

[24] Yad Vashem, "Displaced Persons Camps," access re-confirmed 5 July 2020, https://www.yadvashem.org/articles/general/displaced-persons-camps.html#footnote4_8m5pq1o

[25] David Weinberg, *Recovering a Voice*, (Liverpool: Littman Library of Jewish Civilization in association with Liverpool University Press, 2015), 28

[26] Fred Terna, "A Fourth Set of Notes for the Shoah Archive of the Abraham Joshua Heschel School," 2 November 1998

[27] Bryant, *Prague* 178

[28] Bryant, *Prague* 209

[29] Weinberg, *Recovering* 33

[30] Daniel Terna, "My First Wife Stella," HD Video, 2013, http://www.danielterna.com/my-first-wife-stella-movie

[31] Weinberg, *Recovering* 17

[32] Weinberg, *Recovering* 32

[33] Ed. Philip E. Ogden and Paul E. White, *Migrants In Modern France: Population Mobility in the Later 19th and 20th Centuries*, (London, Unwin Hyman, 1989), 47

[34] Viktor Frankl, *Man's Search for Meaning*, (Boston, Beacon Press, first published in German in 1946 under the title *Ein Psycholog erlebt das Konzentrationslager*; first English language edition 1959), 6

[35] Rosemary Wakeman, *The Heroic City: Paris 1945-1958* (Chicago, University of Chicago Press, 2009), 21

[36] JDC [Joint Distribution Committee] Archives, "Introduction, History of JDC," access re-confirmed 5 July 2020, https://archives.jdc.org/our-stories/history-of-jdc/

[37] United States Holocaust Memorial Museum, "American Jewish Joint Distribution Committee Refugee Aid," Holocaust Encylopedia, access re-confirmed 5 July 2020, http://www.ushmm.org/wlc/en/article.php?ModuleId=10005367

[38] American Jewish Archives, Samuel L. Haber Papers 1920-1988, Manuscript Collection No. 584, access re-confirmed 5 July 2020, http://americanjewisharchives.org/collections/ms0584/

[39] Jewish Telegraphic Agency, "Samuel Haber Dead at 81," 5 November 1984, access re-confirmed 5 July 2020, http://www.jta.org/1984/11/05/archive/samuel-haber-dead-at-81

[40] JDC [Joint Distribution Committee] Archives, Accounting Letter #8864-SS referencing Lucy Hoddes, access re-confirmed 5 July 2020, http://search.archives.jdc.org/multimedia/Documents/NY_AR_45-54/NY_AR45-54_Count/NY_AR45-54_00008/NY_AR45-54_00008_00240.pdf

[41] Weinberg, *Recovering* 68-70

[42] Weinberg, *Recovering* 75

[43] United States Holocaust Memorial Museum, "The Kielce Pogrom: A Blood Libel Massacre of Holocaust Survivors," Holocaust Encyclopedia, access re-confirmed 5 July 2020, https://encyclopedia.ushmm.org/content/en/article/the-kielce-pogrom-a-blood-libel-massacre-of-holocaust-survivors

[44] Weinberg, *Recovering* 187

[45] Caroline Bækkelund Hauge and Camilla Wernersen, "60 Years Since the Tragedy," access reconfirmed 8 August 2020, https://www.nrk.no/osloogviken/60-ar-siden-tragedien-1.6872930

[46] Natan P.F. Kellerman, *Holocaust Trauma: Psychological Effects and Treatment,* (Bloomington, iUniverse Books, 2009), Kindle edition location 1072

[47] Terna, "My First Wife Stella"

[48] Kellerman, Holocaust Trauma, location 706

[49] Terna, "My First Wife Stella"

[50] Psychology Today, "Gestalt Therapy," access re-confirmed 5 July 2020, https://www.psychologytoday.com/us/therapy-types/gestalt-therapy

[51] Boyce Rensberger, "Amphetamines Used by a Physician To Lift Moods of Famous Patients," The New York Times, 4 December 1972, access re-confirmed 5 July 2020, https://www.nytimes.com/1972/12/04/archives/amphetamines-used-by-a-physician-to-lift-moods-of-famous-patients.html

[52] "Obituary: Stella Terna," The New York Times, 27 March 1983, access re-confirmed 5 July 2020, http://www.nytimes.com/1983/03/27/obituaries/stella-terna.html

[53] Fred Terna, "A Fourth Set of Notes for the Shoah Archive of the Abraham Joshua Heschel School," 2 November 1998

Acknowledgements

First and foremost, I must thank Fred, Rebecca, and Daniel for opening your doors, hearts, minds, and memories to me and making this project possible. Fred, I have learned more from this time together than can possibly come through this book. Rebecca, your faith in me to figure out, work through, and complete this project has meant the world. Daniel, your commitment to sustaining your father's legacy is what allowed this book to be, including the time you gave me, reading drafts, sharing notes, exchanging emails, and hugely: TAKING PHOTOS so that readers can catch a glimpse of the world and work you know so well.

I also have tremendous thanks to my parents and brother for seeing me through this. Dad, you edited, read, reread, edited, connected with museums and scholars on my behalf, edited, and reread. You took this project from my computer to over the finish line when I

wasn't sure how to get it there myself. Mom, you have cheerleaded, comforted, asked questions, provided feedback, and made sure I had all the support I needed to get to the end. Jesse, you started this in the parking spot across the street and in Fred's kitchen, asking the important questions and getting too few answers so that this project was born. My wonderful family-in-love, Gary, Marlene, and Steve, walked the line between asking enough to know that you care and not so much that you overwhelmed me. So much gratitude to my aunts, uncles, and cousins for supporting me in so many ways through this process. Thank you.

Amy Oringel, my amazing editor, you convinced me that this story was mine too and helped me rewrite it into what it has become. Vardit Samuels, my personal librarian, who did all the background research a non-historian could ask for to fill in the blanks, including finding "Prague in Black" and "Recovering a Voice," both of which I reference throughout. Naomi Berger, who volunteered your time, energy, and expertise, even with a second grandchild added to the mix in the middle, to lay this book out and make it a physical reality.

So many others have contributed to this being successful as well: Ladies Who Brunch (Vardit, Emily, Sarah, Sara, Ariela, Leah, and Robin), Zion for trading photos for bagels, and Kane Street's Finest (Miriam, Emma, Eve, and Elizabeth), Rebecca, Ellen, Dwayne, Catherine, Sarah, Kyi, Liz, Anna, and so many many other friends and family members: You have all been with me on this journey the entire time, have let me tell stories and grapple with uncertainty with love and care. You let me co-opt what should have been catch-up and actual conversation to just talk about this project for hours on end.

Finally, most importantly, Brian. You have held all of my excitement,

tears, and passion for the many years of this project. Fred once called you "the silent participant making this project possible" but for me, you were the most necessary partner to starting this in the first place, seeing it to fruition, picking up all the slack I dropped, encouraging me not to give up, and buoying me when I felt like I was drowning. This is ours.

About Fred Terna
& His Art

Frederick Terna's canvases [are] thick with texture and fiery scenes. — *Nina Strochlic, National Geographic*

Fred Terna's ink drawings, dating from 1945 to 1952, reveal a mind eager to absorb and remember. . . .Every line and architectural detail exists in its own self-sustained universe, privileging a felt logic over a faithful visual representation. In other words, the act of drawing burned scenes into the artist's mind one by one. — *Louis Block, Hyperallergic*

Everything is personalized by an exacting sense of internal scale and by being brought to a material fullness of surface appropriate to each image. — *Stephen Westfall, Bomb*

Though the style [of his ink drawings] varies widely, Mr. Terna's zeal in gathering visual details is leavened by the obvious joy he took in recording them. —*Will Heinrich, The New York Times*

Frederick Terna has a soft touch. His images are neither strident nor angry. The horror behind many of them is paradoxically softened by symbols and metaphors. He is not an illustrator; indeed much of his work over the last sixty years is abstract. Yet there is nothing abstract about the journey Frederick Terna has taken from April 1945 until today. He has lived through one of the defining events of the 20th century, [and] managed to . . . get up day after day, enter the studio and make art — again and again — that defeats the evil that was done to him so many years ago. — *Richard McBee, The Jewish Press*

[In the Holocaust documentary "As Seen Through These Eyes,"] Frederick Terna explains how creating secret artworks gave him a sense of control. He is the closest thing to a philosopher of art in this film. — *Stephen Holden, The New York Times*

I've been privileged to be Fred Terna's Rabbi in Brooklyn for the past 24 years. In all of these years, I have not seen anyone come near the reverence which members show to Fred. Our world is frenetically connected and distracting, but when Fred speaks, all, young and old, tune out pre-occupations and listen with open minds and admiring hearts. Without any pretense, he shares insights into the human condition, which join unapologetic realism with a stubborn, even defiant faith, a clear-eyed understanding of our capacity for evil with a prophetic insistence on decency and justice. His influence is as powerful as it is modest. I thank and love Fred for always expanding my understanding and affirming my hope. — *Rabbi Sam Weintraub, Kane Street Synagogue*

See more of Fred's work on his website: https://frederickterna.com/
Learn more about Daniel's photography: https://danielterna.com

About the Author

Julia Mayer is Director of Philanthropy at Year Up, a nonprofit that provides workforce development training for 18-24 year olds. Julia's first book, the young adult novel "Eyes in the Mirror," was published in 2011 by Sourcebooks.

Julia has a Masters in Management from Harvard University, a BA in Philosophy and Psychology from Boston University, and is a graduate of Bard High School/Early College. An avid swimmer and kayaker, she lives in Boston, MA with her husband.

Julia can be reached through her website www.juliamayer.com

Photo credit: Lili Boxer